JEROME C. ROBINSON, M.D., F.A.C.C.

Handcoloring
PHOTOGRAPHS

Handcoloring
PHOTOGRAPHS

by James A. McKinnis

AMPHOTO
an imprint of Watson-Guptill Publications
New York

Photograph © 1989 by L. Cory, handcolored by J. McKinnis.

James A. McKinnis is a professional handcolorist whose clients include the Bolshoi Ballet, the Dallas Cowboys, Compaq Computers, Miller Beer, and the San Antonio Grand Prix. His work has appeared in many magazines, including *Darkroom Photography*, and on the television program, *PM Magazine*. McKinnis enjoys photography too much for his own good, he thinks, because he would rather do it than almost anything else. He lives in San Antonio with his wife, Diane, and son, Dylan, who does his own brand of handcoloring.

First published in 1994 in New York by AMPHOTO, an imprint of Watson-Guptill Publications, Inc., a division of BPI Communications, Inc., 1515 Broadway, New York, NY 10036.

Library of Congress Cataloging-in-Publication Data

McKinnis, James A.
 Handcoloring photographs / by James A. McKinnis
 Includes index.
 ISBN 0-8174-3972-2:
 1. Photographs—Coloring. 2. Photography, Handworked. I. Title.
 TR485.M45 1994 93-41704
 771'.44—dc20 CIP

Manufactured in Hong Kong

1 2 3 4 5 6 7 8 9 / 03 02 01 00 99 98 97 95 94

Edited by Robin Simmen
Designed by Jay Anning
Graphic production by Ellen Greene

I sincerely want to thank all of the artists who contributed their images and experience to this book. While gathering work from them, many friendships have begun. I've gained from this, and hope in the future that we'll collaborate again.

I also want to thank the generosity and cooperation of the manufacturers that provided information and products for me to test. They include: Agfa Corporation, Berg Color-Tone, Brandess/Kalt Company, Eastman Kodak Company, Eberhard Faber Company, Fuji Photo Film, GMI Photographic, Ilford Photo, Luminos Photo Corporation, Oriental Photo Distributing Company, Suregard, and M. Grumbacher, Inc. Without their help, the book would have been far less complete.

I also want to thank Charlene Rathburn of the Martin Rathburn Gallery in San Antonio, Joshua Paillet of the Gallery for Fine Photography in New Orleans, and Dan Fear of the Silver Image Gallery in Seattle for their generous assistance in putting me in touch with many of the contributing artists. I thank the Xochipilli Gallery in Birmingham, Michigan, for letting me include Rita Dibert's work. Finally, I want to thank a personal friend, Don Beardslee, for his continuing help and support.

CONTENTS

INTRODUCTION

My business card describes me as a "handcolorist." Some people are confused by this occupation; in fact, a woman once asked, with a perfectly straight face, whether I colored hands for a living. So I think it would be wise to begin this book with some basic definitions.

Handcoloring photographs is a phrase that describes any application of color to a black-and-white or toned photographic print. It sometimes is used to refer to the overall field of handcoloring, and in the United States it has generally replaced the use of the word *handtinting*, a term that has had a more narrow meaning. In a handtint, the entire photographic image can be seen through a translucent color application, with no details obscured by the color medium. In this book, the word *handcoloring* is used instead of handtinting.

I also specialize in *handpainting* photographs, which I define as applying opaque color that covers portions of the underlying photographic print; however, the photographic content or subject matter is not significantly changed or modified. For example, if my subject is a car, I might use color to obscure a shadow or some unwanted background, but I don't end up transforming the car into an airplane. Both in technique and appearance, there is a significant distinction between handcoloring and handpainting, but I practice both and this book covers both.

The purpose of this book is to teach you how to handcolor photographs by describing proven materials, presenting the basic techniques, and giving you some helpful suggestions for selecting and preparing the photographic print. I also cover such special techniques as minimal color, ultracolor, and handpainting. While there are many schools of handcoloring practiced today, it is my belief that by beginning with simple, established, and effective methods, you'll increase your rate of success from the outset. Once you understand the basics, you can better explore the variety of techniques introduced by the other artists in the second part of the book; their work is included to encourage you to experiment and develop your own individual style.

Since the earliest days of photography, people have been coloring photographic images by hand. Until very recently, their motive was strictly to add "realism" to black-and-white photographs. Color is often equated with realism. For example, thirty years ago, people rushed out to buy color televisions to replace their black-and-white sets, although those who recall the early color television pictures know it was a stretch of imagination to extract reality from those primitive images. More recently, there has been a controversial movement to colorize old black-and-white films for the same reason—that adding color makes images more "realistic" for general audiences.

When a practical means of manufacturing and developing color film arose in the 1930's, handcoloring disappeared as a popular way to achieve color realism. A decade later, the author of a book promoting handcoloring acknowledged the new "mechanical process" but felt the future of handcoloring was still strong because it was "far cheaper" than the alternative! However, it is handcoloring's creative potential, not cost, that has kept it alive. As you will see from the diversity of the handcolored

19th century handcolored portrait, from the collection of D. Beardslee, San Antonio.

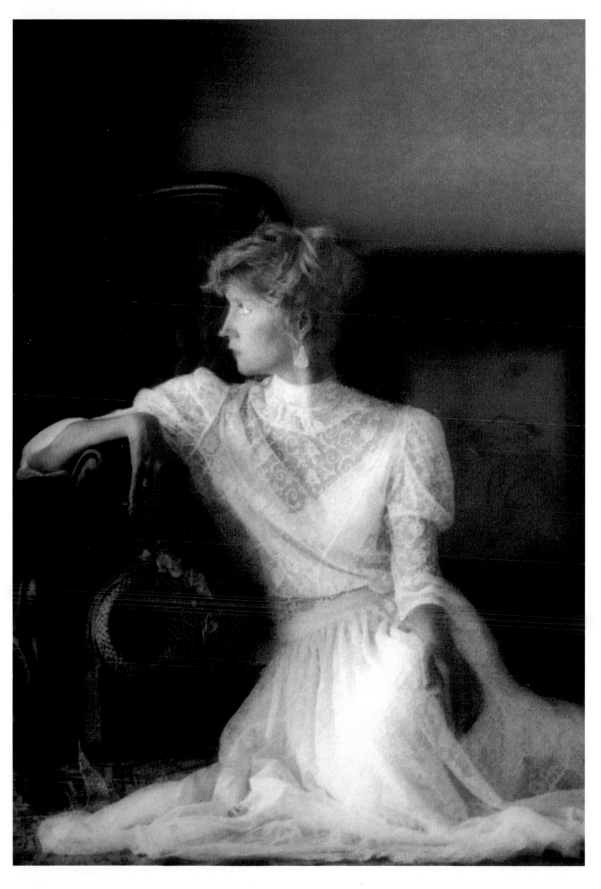

VICTORIAN PORTRAIT, handcolored on Luminos Charcoal paper.

Handcoloring this contemporary portrait gave it a nostalgic feeling. I shot the photograph on Tri-X film with available light indoors at a boutique.

images in this book, there is nothing "old-fashioned" about today's handcoloring work. A wide range of styles and techniques provide handcolorists with unparalleled possibilities for working with photographic images.

Although I don't want to ignore the history of handcoloring, the role it plays in photography today has little to do with nostalgia and much more to do with artists seeking new ways to creatively manipulate their images. The artists in this book are fine-art or commercial photographers, or both, and not "retouchers" or traditional colorists.

Critics are just beginning to recognize contemporary handcoloring as a distinct form, separate from historical handcoloring, and a creative new force in photography. For example, in 1985 a journalist doing a story on my handcoloring called two major photographers for their opinions about the field. Both told her that handcoloring was "dead"; I had to convince her otherwise. In 1990, an encouraging sign of changing times was the December issue of *Decor* magazine, devoted to "photo art." In it, a writer stated that "handcolored images have evolved into the fine art of the '90's," which was a strong comeback from the obituaries five years earlier.

Contemporary handcoloring has few boundaries. Since realism is the domain of a variety of technically excellent color films, today's handcolorist is free to produce purple skies, blue cardinals, and outrageously multi-hued zebras such as nature never intended. Handcoloring can also look realistic, but that is your choice. Realism is only one of many effects you can opt to achieve. Once you have mastered good handcoloring techniques, you will be in a position to choose your own sense of style.

I began my career in handcoloring when my brother-in-law bought a small portrait photography studio that had never converted to color film, and I became his apprentice. Although we had no intention of doing handcoloring, the previous owner offered us some tips on how to achieve good flesh tones. I happened to hear him say that brown toning was the way to get the necessary base warmth. He also stressed the importance of using paper with a surface receptive to coloring. To be perfectly honest, I had no fondness for the look of traditional handcolored portraits, associating them more with morticians' art than with photography. Due to our lack of interest in handcoloring, we didn't even touch the boxes of photo oils he left behind for more than a year after we were in the studio.

Then my aunt, who was preparing family pictures for relatives, sent some portraits of my grandparents to me to copy and reprint. I was intrigued by the fact that they were faintly tinted, and one day decided to see whether I could do the same thing. I also began trying other photographic directions, including airbrushing, but gradually found that I liked the effects I was obtaining from taking a picture in color, printing it on Kodak Panalure Portrait paper, and coloring it lightly. It also proved very popular with clients.

When Kodak discontinued that paper, I was forced to find an alternative, which I did in Agfa Portriga-Rapid, a black-and-white paper. Although not intended for use with color negatives, it worked well with them and was excellent for handcoloring. Agfa's advertising agency saw my portfolio in New York and offered to feature my work in an ad. With this recognition, I began to devote most of my photography to experimenting with handcoloring. Since then I've conducted many handcoloring workshops, exhibiting and demonstrating the techniques I've evolved.

Information on handcoloring is almost as scarce today as when I began fourteen years ago, which is why I wrote this book. By trial and error, I've developed a method that is effective and versatile, yet simple to demonstrate and teach. The biggest problem I see with today's handcoloring stems from colorists' lack of information about flesh tones. Traditional colorists knew how to create reasonably warm, rosy, flesh tones because their aim was realistic representation. Today, however, what I keep seeing in others' work is cold, bluish skin. There is a big difference between creating blue flesh tones on purpose and doing so from ignorance. I felt it was necessary for me to share the information I'd learned and to strip some of the mystery from the field.

When the opportunity to do this book appeared, it expanded into a chance to survey developments in handcoloring by some of the major handcolorists in North America. The results, seen in Part II of this book, are worth celebrating. Handcoloring is alive and well, and is growing in complexity of style and technique. Gathering the work of twenty top-notch professionals, I decided, whenever possible, to let the artists explain how they achieved their effects in their own words. Where I've attempted to describe their work or edited their words, I hope I've done justice to their efforts, as you can see the excellence and diversity of their work for yourself.

Writing this book has brought me a great deal of pleasure. It has certainly been exciting to see what is being done by other artists and to help them share their methods and "secrets." Each artist in this book has his or her preferred method of working. In some cases, the artist employs a variety of techniques, choosing those that best suit

the print to be colored and their intent for the final image.

These artists are educators who wish to share with you what they've learned from years of exploring the medium of handcoloring. Obviously, they've chosen directions that are personally interesting. They've also made choices about how to combine their handcoloring work with other parts of their lives and careers. In some cases, they do fine-art photography—handcolored work for its own sake—and in others, handcoloring is one of several focuses they have in photography or art. They are also teachers and writers, researchers and commercial artists, offering their work in the marketplace of ideas and promotion. They have made their choices—now it is time for you to learn what you can do with handcoloring.

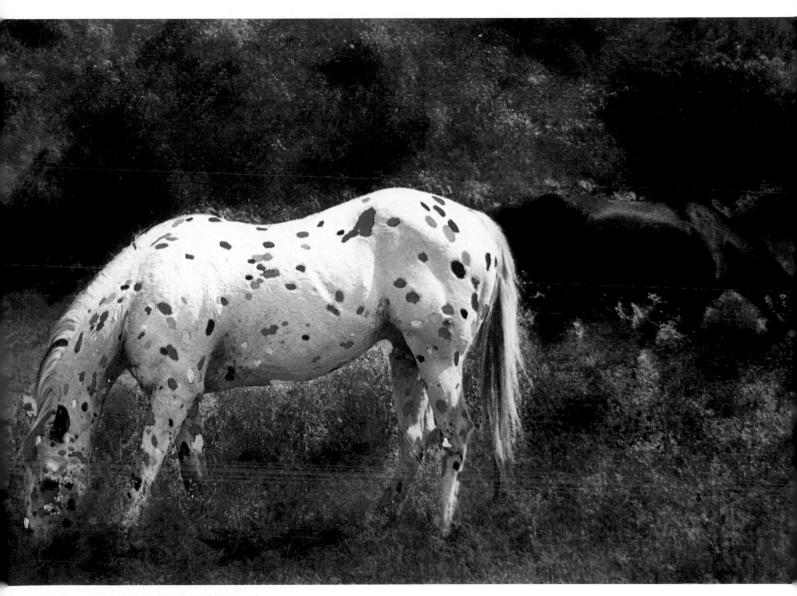

OLD PAINT, handpainted with Marshall Photo-Oils.

I photographed this Appaloosa horse on Fuji Neopan 400 color film and printed the image on Luminos RCR paper. Although he really was spotted, coloring his spots was my idea.

Part One
BASIC SUPPLIES AND PROCEDURES

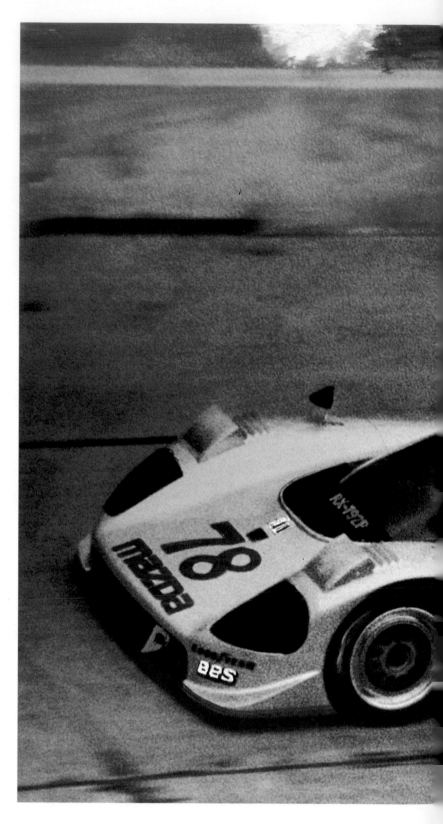

MAZDA #78, handpainted on Luminos RC Pastel Silver paper.

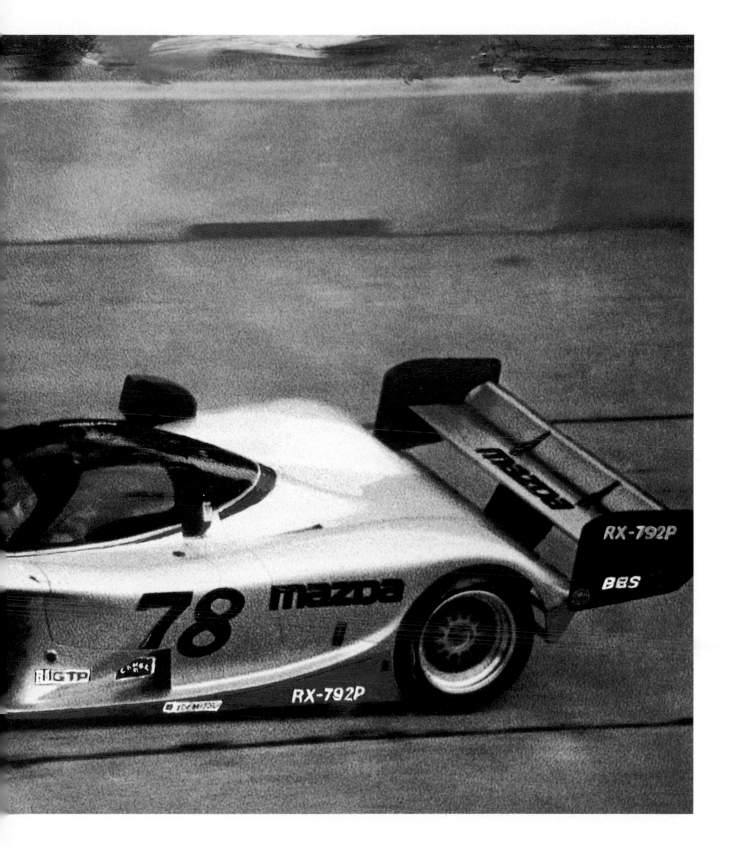

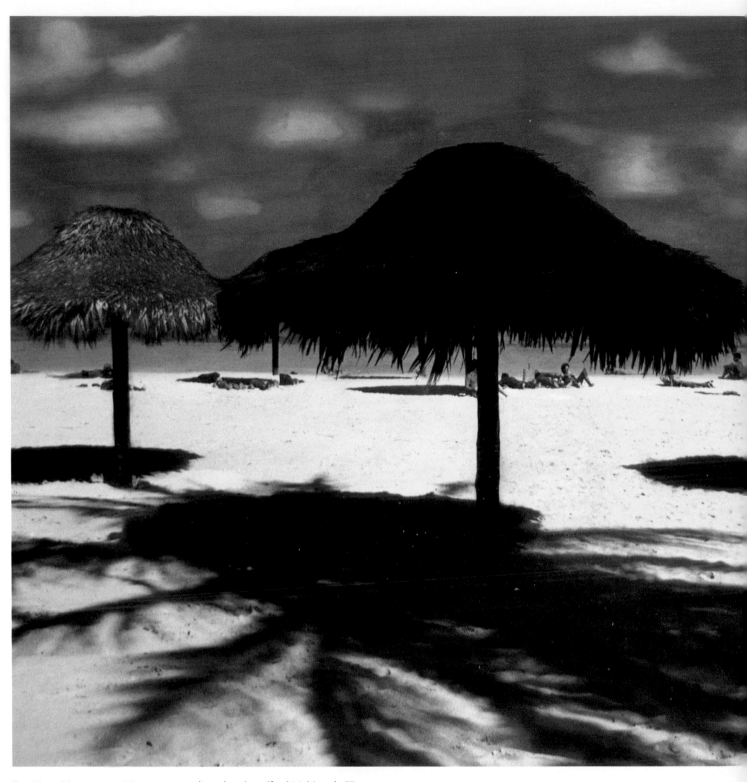

TOO MANY MARGARITAS IN MARGARITAVILLE, ultracolored on Ilford Multigrade FB paper.

The Photographic Print

PREPARING A GOOD black-and-white photograph for handcoloring is like stretching a canvas for painting; careful work at this stage means fewer problems later. Generally, avoid excessive contrast in your print, as this reduces details in shadows and highlights, and you want details to show through the color you are going to apply. Also, color is less effective when it overlays deep shadows. The print shouldn't be too "flat" in terms of contrast but should simply have a good range of tones.

Print your early handcoloring efforts on paper that is at least 8 x 10 inches. Smaller prints mean smaller details, which makes coloring more difficult. Print the image with a 1-inch border around it instead of printing to the edge of the paper. This will allow you room to tape the print to your working surface.

CHOOSING A PAPER

The photographic paper you select for the print has a great impact on the kinds of results you get from handcoloring the image. There is no single ideal paper for handcoloring, but there are a number of excellent ones. You can obtain superior results with any of the papers mentioned in this book. Try several and see which ones you prefer. You might find, as I do, that you like certain papers for different kinds of subjects; for example, a smooth, matte-surfaced paper for cars, and textured paper for still lifes.

Basically, there are two types of photographic enlarging papers: resin-coated (RC) and fiber-based. Resin-coated papers are popular for their simple processing in the darkroom. Their layer of resin retards photo chemicals from contaminating their paper base, which greatly reduces the time necessary for processing the print. Even working without a mechanical processor, the time it takes from start to finish to make an RC print is a matter of minutes, including drying time for the print. Fiber-based papers, on the other hand, require significantly more time to fix the image, much longer to wash, and longer to dry. Their advantage is their greater absorbancy; RC papers can't grab coloring agents as well, generally resulting in less of a color effect. While I have yet to find an RC paper as versatile as the best fiber-based papers, many handcoloring artists use RC papers and like the results they obtain.

Resin-coated Papers. Some handcolorists try to counteract the absorbancy problem with RC paper by applying a precolor spray to the print (see page 28) to increase the tooth—the retaining capability of the paper—by creating a rougher surface. I've found this method to be limited in value, preferring instead to use a paper that has a more "user friendly" surface. In my opinion, the best and most versatile RC paper for handcoloring is Luminos RCR (the acronym stands for Resin-Coated Rough). Its surface is actually intended for artistic manipulation and is readily absorbant, hence very versatile. In addition, Ilford Multigrade III RC Rapid matte paper yields impressive results, and Kodak has recently introduced P-Max Art RC paper, made especially for handcoloring.

Until recently, I told students to avoid RC papers completely because I found RC surfaces too hard to work with to obtain satisfactory results. I've overcome my objections largely due to positive experience with the Luminos RCR paper, so I suggest you give some of the papers I've mentioned a try and see how they work for you. Two good reasons for using RC papers involve time and environmental concerns. As a Kodak representative pointed out, using RC papers is better for the environment because they require less time in chemical baths and less water to wash them clean.

Resin-coated papers are also great when time is of the essence. Recently, I was working with an art director who had an overnight deadline for delivery of a finished mechanical for a record album cover. I was able to produce the image he needed with lightning speed because I used RC paper. I cautioned him that the picture had to be handled with extreme care because the photo oils hadn't dried, but nonetheless the image could still be used for color separations. A fiber-based print would have required time to dry from its processing prior to the coloring stage. Hence, working with RC papers is sometimes the only practical choice.

Fiber-based Papers. These are the traditional black-and-white paper stock for both photographers and handcolorists. While hard, glossy surfaces don't accept most handcoloring effects, matte- and textured-surface fiber-based papers from several manufacturers provide excellent results.

Fifty years ago, when traditional handcoloring was still the popular way to make colored photographic images, an author writing about handcoloring recommended almost 40 papers. While most of these have disappeared, a number of good papers are available. Agfa Portriga-Rapid 118 is excellent and versatile. Its slightly textured semi-matte surface is very absorbant. GMI Photographic, a New York distributor, recently introduced two Forte Elegance papers from Hungary—Bromofort and Fortezo—which are outstanding for handcoloring. Both are available in a smooth matte finish that absorbs oil perfectly, and I recommend them highly. One of their subtle advantages is that their smooth surfaces add no unwanted texture to images. Depending on your subject matter, this quality can be quite important.

Ilford Multigrade FB matte is also an excellent paper. I've had best results with it when I pretreat its surface with a special solution prior to coloring (see page 28). Kodak manufactures a number of fiber-based papers with a fine-grain, luster surface (designated as a "G" surface) that is completely receptive to photo oils. And in addition to the Luminos RCR paper mentioned earlier, Luminos makes several outstanding fiber-based papers similar to traditional textured surfaces that are no longer available. Oriental, a brand of paper distributed by Brandess/Kalt (the manufacturer of Marshall Photo Oils), includes some fine, fiber-based papers. These are somewhat limited in their ability to absorb photo oils, but Oriental has a committment to handcoloring and hopefully will improve that aspect of their otherwise excellent paper.

The Absorbancy Factor. Now that I've surveyed some photographic papers appropriate for handcoloring, I want to discuss more thoroughly a critical quality to which I've already alluded, something that I call the "absorbancy factor." This refers to a paper's ability to accept a coloring medium and retain it during the coloring procedure. While absorbancy can't be quantified, I consider it a highly important paper characteristic for two reasons. First, when you are coloring a print, you want the color to change the print and become part of it. If the photo oils aren't absorbed into the print itself, they will disappear when you wipe them away as part of the basic handcoloring process, and color disappearing completely is a very frustrating problem. Hard, glossy surfaces absorb almost no coloring; the best you can hope for is a minimal pastel effect. Granted, this might be lovely in some cases, but it is limiting.

Second, the more absorbant the paper surface is, the more you can control the intensity of the color. Not only do you see more results from your application, but you also have more choices about how color affects your subject. For example, I envision ballet mainly in a palette of pastels, but I imagine carousels rendered in bright, saturated color, and I want to be able to achieve both effects. The paper you choose will, based on its absorbancy factor, give you a range of control that dictates how saturated your color can be. Keep this in mind when your image is printed.

If you do your own darkroom work, look for the papers I've described and give them a try. If you have a commercial photography lab print your photographs, ask whether they have these papers available and insist on knowing what they use. Believe me, not all papers are created equal when it comes to handcoloring. Even before you apply the first touch of color to your print, you've already made some critical choices about how well the handcolored image will look, which is why you can't underestimate the importance of the print.

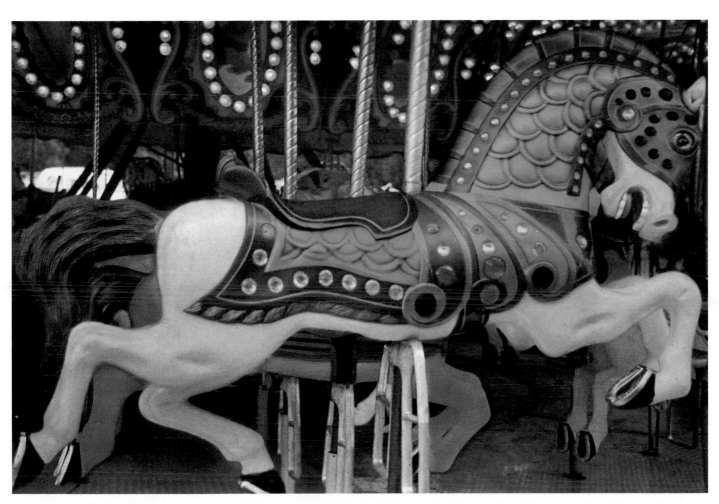

Carousels are ideal for handcoloring on highly absorbant photographic paper so that you can render them in bright, saturated colors.

TONING YOUR PRINTS

Toning a photographic print involves replacing its metallic silver compounds with a chemical solution that changes the darker areas of the print to another color, while the lighter areas remain largely unaffected. Because toning affects the overall background color of a print, this is a creative option you might wish to explore. As I mentioned in the Introduction, to make warmer flesh tones, a brown- or sepia-toned print is a more effective canvas than a black-and-white print. You might wish to test this yourself by taking identical prints, toning one, and then handcoloring both to evaluate the difference that a toner can make. Toners that produce red, blue, green, yellow and gold tones are also available.

If you are considering toning prints yourself, carefully follow the instructions given by the individual toner. For example, most sepia toners require the print to be bleached before toning it. This involves immersing the print in a chemical solution while the image is visibly "bleached," or reduced significantly. The print is then rinsed and bathed in a second solution that restores the image in a golden-brown sepia. Other toners are just one step.

Some toners require different kinds of exposures for the print in order for the final toned image to look right. For example, bleaching tends to reduce the tonal values of the print, making it appear somewhat washed out and underexposed. On the other hand, other toners have just the opposite effect—that is, they darken the print, making it look as if it were overexposed during printing.

I suggest you do some reading about toning and conduct some experiments in the darkroom. For example, try printing a negative correctly first, then print the same image with a half-stop underexposure and a half-stop overexposure. Tone all three, and see which exposure most closely meets your expectations for the toned image. Although this is a time-consuming process, once you have the information you need and you record it for later reference, you should be able to predict how that toner will react. Then you can adjust your printing accordingly.

Interesting effects with toner can be achieved by masking a portion of your print to prevent it from being toned. Rubber cement or liquid frisket can be painted onto the image, so that the toning takes place only on the unmasked part of the print; the masked portion remains black and white. Liquid frisket is an artists' material that dries reasonably quickly, yet retains a rubber-like consistency and doesn't usually damage photographic surfaces. After the toning, you can easily remove the frisket by gently lifting its edge and peeling it back. A number of liquid friskets are availabe, including Miskit, made by Grumbacher. When you buy a liquid frisket, check to be sure it works with photographs as well as with other kinds of art.

A variation of masking that requires considerable practice and experimentation is to "split-tone" the print: masking a portion of it and toning it with one toner; then, after the print has been correctly washed and dried, reversing the masking procedure and toning the print with a second toner. In effect, this creates a two-toned print.

Among the hard and fast rules for toners is working with a print that has been correctly fixed and completely washed (most toners work best if the fixer is a nonhardened hypo fix solution). A complete wash removes impurities that otherwise remain unseen until toning, when stains would appear, ruining the print. With the exception of using a hypo-clearing solution to reduce final wash time, there are no shortcuts to this procedure, either before or after the toning process. After toning, follow the manufacturer's directions explicitly regarding another final print wash and any other steps you must take to complete the process.

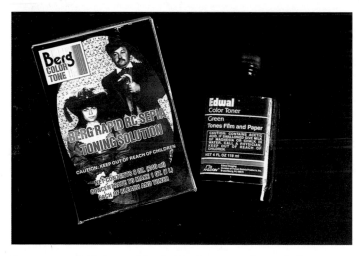

Toners are available in a variety of colors from several manufacturers. Using the Berg Rapid RC Sepia Toning Solution on the left is a two-step process that involves bleaching the print before toning it. The Edwal Color Toner is a one-step solution for green toning.

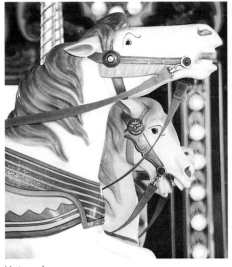

Untoned

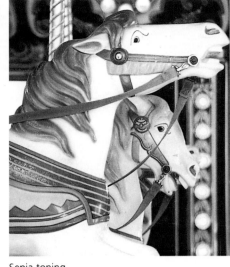

Sepia toning

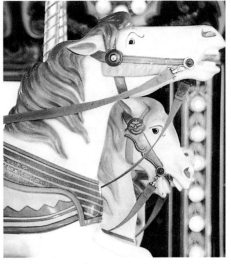

Brown-copper toning

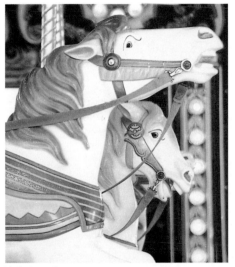

Yellow toning

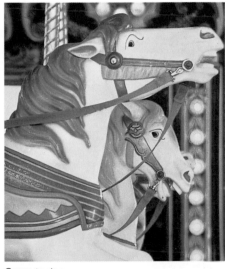

Green toning

Red toning

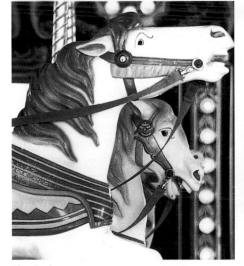

Blue toning

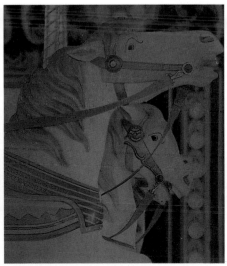

Red and blue toning

Compare these prints of the same black-and-white image, toned with seven colors. The differences are sometimes subtle, sometimes vivid, but all create very different color bases for handcoloring.

UNUSUAL PAPERS AND PHOTO LINEN

In addition to traditional photographic papers, there are other photographic surfaces that handcolorists use to print and color their images. Luminos is a small, New York-based company with one of the most exciting lines of photographic enlarging papers on the market, including papers that are silver and black, pastel colors and black, and gold and black. They also produce a black-and-white photographic emulsion imbedded in a linen cloth.

Working with Luminos RC Pastel Silver paper has been especially rewarding for me. This paper produces silver-gray highlights and traditional blacks, and mid-tones are affected somewhat by the silver base. The results are very exciting for me because I do a lot of images of automobiles and sports subjects in which there is an association with silver, such as the Silver and Black San Antonio Spurs basketball team.

Another favorite paper of mine is Luminos RC Pastel Ivory. The base hue is a gentle ivory as opposed to white. The surface of this semi-matte RC paper accepts a light coloring, and its ivory tone gives prints a vintage look.

Perhaps Luminos' most exciting product is their Photo Linen. Imagine printing an image exactly the same way you would print a regular black-and-white photograph: developing it, stopping the process, fixing the photograph, and then washing it. However, what you end up with is a picture on a canvas-like material that can be attached to stretcher bars just like an artist's canvas. Photo Linen is very receptive to photo oils and highly absorbent, just like a fine paper. Creating a stretched art piece that resembles a painting as much as a photograph, and being able to frame and present it in the same manner, has generated a lot of excitement among my clients and my students, too.

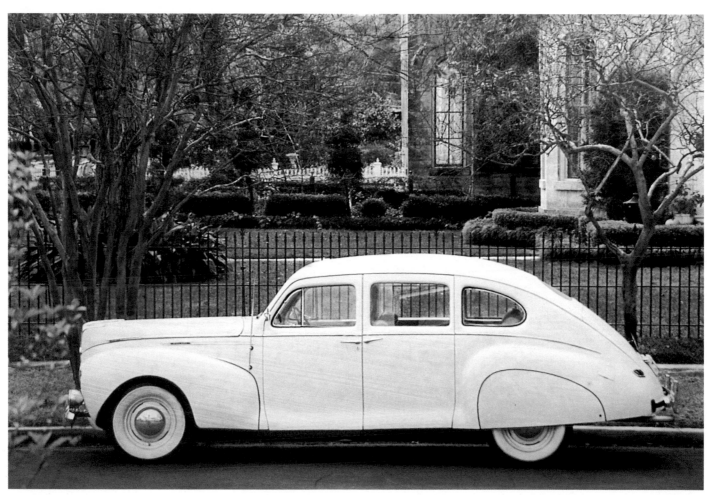

I handcolored this photograph of a 1940 Lincoln sedan on Luminos RC Pastel Ivory paper to give the entire image a vintage look.

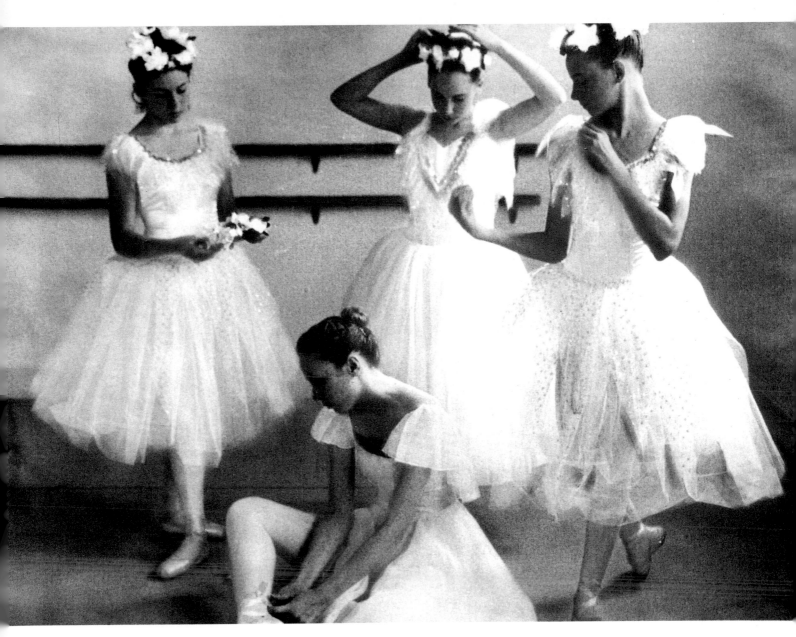

This softly lit, feminine scene was perfect for
printing and handcoloring on Luminos Photo Linen.

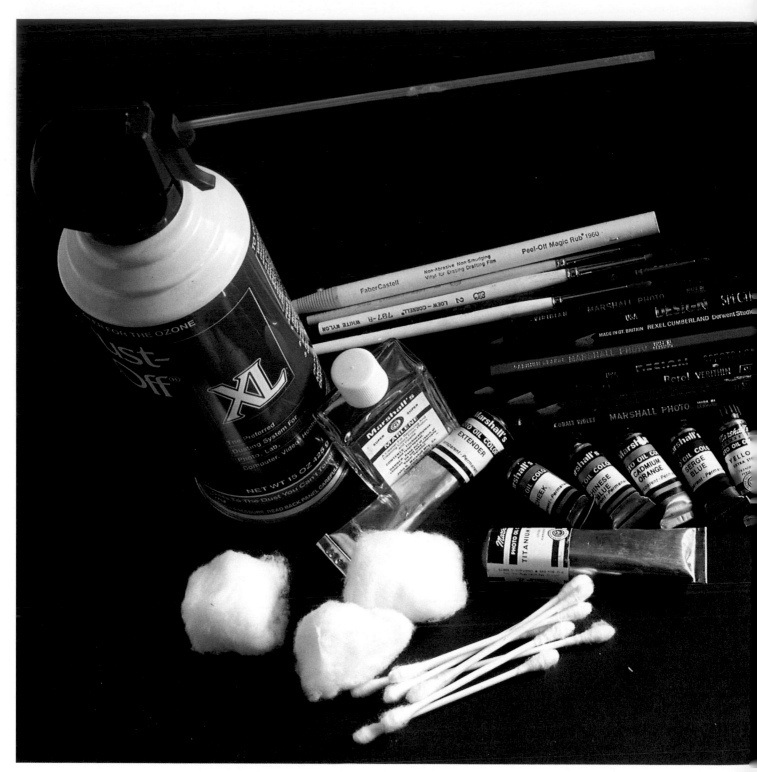

Supplies for handcoloring work include (clockwise, from top left): a can of Dust-Off, a Faber Castell Peel-Off Magic Rub vinyl eraser, sable paint brushes, Berol Prismacolor pencils, Design Spectracolor pencils, Marshall Photo pencils and tubes of oil, skewers for puncturing oil tubes, toothpicks, cotton swabs and balls, a bottle of Marshall Marlene Solution, and a tube of Marshall Photo-Oil Extender.

Materials and Workspace

HANDCOLORISTS use many different materials to create their images. Some of these supplies and coloring mediums are familiar to fine artists; others are commonly used by photographers; and some, such as photo oils and pencils, are made specifically for handcoloring photographs. Photo oils and pencils are the most effective coloring agents for handcoloring, and they are very easy to use. I recommend that beginners work with them to learn the basic procedures outlined in this book before experimenting with different kinds of color. Other necessary equipment includes cotton swabs, cotton balls or bulk cotton, a vinyl eraser, canned air, an unblemished work surface, and drafting tape. Finally, working in a quiet, well-lit area is optimal.

PHOTO OILS AND PENCILS

Although a variety of materials can be used to color photographs, I will focus on the two that I consider most effective and easiest to use: photo oils and pencils. Without reservation, I think that photo oils are the most versatile medium available, and to me they are synonymous with Marshall Photo-Oils. While other photo oils have been sold, Marshall's has always offered the widest color selection, thus reducing the need to mix colors. Specifically manufactured for handcoloring photographs, Marshall Photo-Oils offer a huge range of colors, including a line of Extra-Strong colors that I really like. They are easy to apply to prints and to manipulate, and they are very "forgiving" when it comes to correcting misapplications, cleaning up overlapping colors, and other mistakes.

Being so easy to use is a distinct advantage of photo oils over retouching dyes. If, for example, a drop of retouching dye inadvertently falls on a print, it must be rewashed for a long time in order to remove the unwanted color. In that case, all the coloring work already done to the print would be washed away, too. That is what I call "unforgiving."

There is a significant difference between the way "photo oils" and "artist oils" perform for the purpose of handcoloring. To test an assertion, recently made by a chief technician for a large manufacturer of artist oils, that artist oils were more intense than photo oils and could be used instead for handcoloring, I compared the two mediums. In every respect, the photo oils proved superior. The consistency of the medium is more fluid and workable, and its texture is more uniform between colors. Although the technician indicated that the intensity of his product was greater, I found Marshall Photo-Oils were stronger. In particular, the intensity of the Extra-Strong Marshall Photo-Oils was without equal.

Second to photo oils, I recommend using photo pencils for handcoloring. Although pencils can't provide the extended range of color effects produced by photo oils, for basic handcoloring and pastel effects photo pencils are excellent, very effective, and easy to use. Visit an art supply store and you'll see an enormous variety of pencil brands and colors. Marshall manufactures a wonderful brand of photo pencils, the best I have found. However, you may wish to experiment with other brands because—unlike photo oils, which are easy to mix together to create specific colors—pencils are limited to their particular hues. Derwent Studio Pencils, a brand from Great Britain, Caran d'ache Supracolor II Pencils, Eagle and Berol Prismacolor and Verithin Pencils all work quite well with photographs. Although pencils can't provide the range of color effects available from photo oils, they are a good alternative method for rendering pastel and basic colors, which you might enjoy trying.

As a general rule, the same papers that can be handcolored with photo oils can be colored with photo pencils. However, there are some exceptions. Pencils are more effective when used on a smooth matte surface rather than on a textured one. Ilford Multigrade FB and Multigrade III matte surfaces are smooth and good for pencils, as are Forte Elegance Fortezo and Bromofort. Also, I've found that pencil color is more vulnerable to a paper's texture than is oil color; color applied by a pencil seems to find its way into the recesses of the texture, leaving a darker residue in those areas.

One of pencils' distinct advantages for handcoloring is the accuracy they bring to application. They simply give you more control over where you put the color, which makes them great for coloring in little details. If you cultivate a light touch, you'll avoid streaking the color as you work it into the print. While there might still be some overlap between colors, it will be minimal, as there is no excess photo oil to be removed. You should still lightly rub the pencil coloring to even out its effect across the colored area, but there won't be a buildup of colors along the borders as with unabsorbed oils (see pages 32–33). I recommend using a clean swab for this rubbing of the pencil application.

Here are some of the basic Marshall Photo-Oil Colors. Each color has been applied over a Kodak Projection Print Scale wheel that shows ten shades of photographic contrast, from pure white to pure black, to illustrate the effect of the color on different tonal values. The colors are, left to right: top row, Carmine, Cerise, and Vermillion; second row, Cadmium Orange, Cadmium Yellow Deep, and Cadmium Yellow; third row, Oxide Green, Tree Green, and Viridian; fourth row, Chinese Blue, Sky Blue, and Ultra Blue; bottom row, Navy Blue, Serge Blue, and Cobalt Blue.

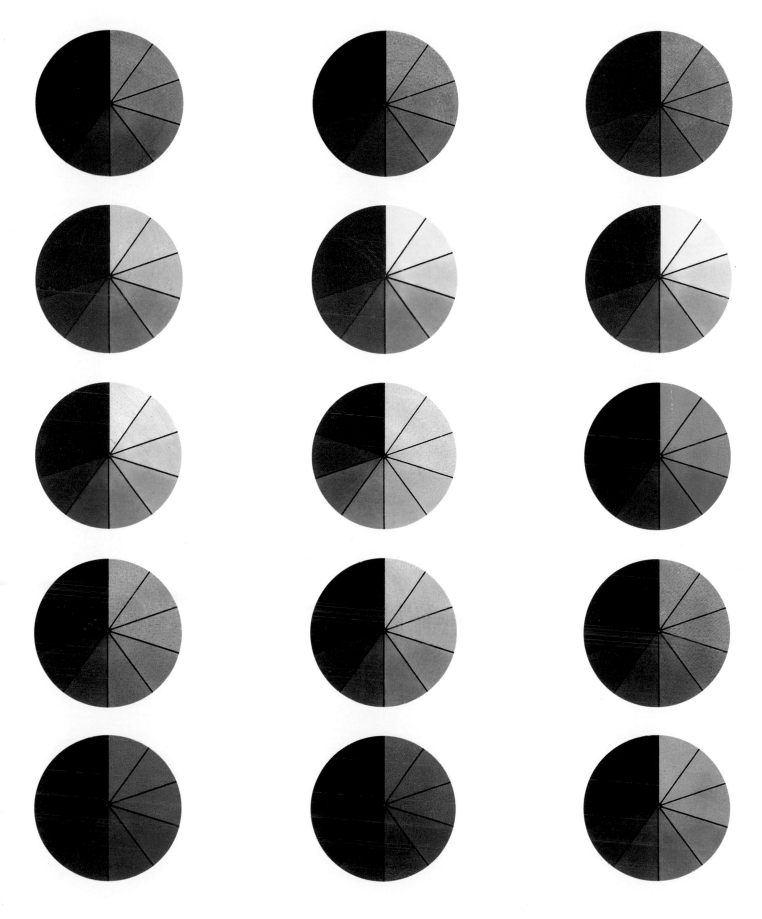

Unlike photo oils, which are applied in the three-step process described in the next section of the book, pencils are practically a one-step medium with a more complete application right from the beginning. You might choose to finish the entire print, then come back and focus on details in certain areas, or you might work directly on the details as you go along. With pencils, the working method is looser, more what pleases you. As a matter of determining your own preference, I suggest you try using pencils early on in your handcoloring career and see how they satisfy you. I've seen some outstanding handcolored work produced entirely with pencils. However, for overall variety of handcoloring effects, I personally rely almost exclusively on photo oils.

TENNIS CLASSIC, handcolored with pencils on Agfa Portriga-Rapid 118 paper.

RETOUCHING DYES AND OTHER COLOR MEDIA

Marshall and Berg both produce fine lines of retouching dyes used by a number of handcolorists, as well as photo retouchers. Essentially, retouching dyes are translucent, colored liquids primarily intended for retouching color photographs. Marshall's Photo Retouch-Colors are sold in sets of eight half-ounce dropper bottles. Assembling all three sets, you would have almost all the colors found in their line of photo oils. The Berg Color Retouching Kit includes ten one-ounce containers with a more limited selection of colors.

Among handcolorists who advocate retouching dyes over photo oils, the consensus is that the dyes penetrate the print, while the oils remain on the surface (of course, the choice of paper would affect this comparison). They also enjoy the brilliance of the retouching colors. Sid Hoeltzell, whose work appears on pages 92–93, combines dyes with oils, putting a layer of dye down first to give a top layer of photo oil more strength. And some handcolorists work exclusively with retouching dyes.

My experience is so limited in this area that all I can offer you is some recommendations. The dyes can be applied to more paper surfaces than photo oils can, and retouching dyes penetrate a paper's surface quickly. Some handcolorists recommend moistening the print prior to working on it with dyes in order to prevent them from soaking into the print too rapidly. They further suggest diluting the intensity of a dye's color before working with it, thereby reducing the problem of introducing too much color to a given area too quickly. Some people apply dyes with sable brushes; others like small cotton swabs. Experiment with both, but in either case, work carefully and precisely, slowly and patiently.

As I mentioned earlier, dyes are very "unforgiving." The only way I've found to erase a mistake made with retouching dyes has been to rewash the print until all the dyes have been removed, which means a return to ground zero. Working with a wet print can help to ameliorate the tragedy of making a mistake with dyes because they aren't as likely to leave a hard edge when they penetrate a wet print as they are with a dry one. Also, diluting the dyes to thin their effect may make them more malleable.

Colored markers are a medium that I find much more enjoyable. The Eberhard Faber Design 2 Art Markers are a line of colored markers that have exciting potential for handcoloring. Obviously intended for graphic arts professionals, these markers are grouped in a variety of hues and intensities, including a range of earth tones and gray tones. In addition, each marker has a broad nib as well as a fine point for more versatile application. Perhaps their single best feature for hancoloring purposes is a colorless blender that can be used to soften an application's hard edges. I've just begun experimenting with this series of markers, but my first results are encouraging. As with retouching dyes, it is important to proceed slowly because errors made with markers are also difficult to correct.

My experimentation with other color media has been limited. Having had such success with photo oils from the start, and because of the great variety of effects they've afforded me, I've had little motive to "switch" to other coloring agents. Yet handcoloring is exactly that—coloring by hand. Other handcolorists use an incredible variety of media, including colored chalk, neon markers, colored inks, pastels, and crayons. There is no reason to avoid them; however, I suggest that you first become familiar with the basic methods for using photo oils and pencils described in this book. This will give you a proven, effective, and versatile method of coloring, using tested products. With that experience to rely on, go in whatever direction you wish to try, knowing that you have a point of departure and a dependable means of achieving the results you want.

MATERIALS FOR APPLYING AND REMOVING COLOR

Cotton is my favorite tool for applying color to the print: cotton swabs, cosmetic cotton balls, and bulk cotton. Cotton is ideal for spreading color evenly, as well as for absorbing excess oil; be sure you always have a good supply of cotton swabs and either cotton balls or bulk cotton on hand. A note of caution: avoid synthetic cosmetic balls, as they are not nearly as effective as 100 percent cotton. Round toothpicks are also handy for coloring fine details. A little cotton rolled onto the point of a toothpick makes a great miniature swab for small, precise color applications.

Some handcolorists use artists' brushes, usually pointed sable brushes, for color applications, particularly for small details. I use a variety of these brushes for handpainting, a technique described on pages 59–67. I suggest that you try applying color with sable brushes as well as with cotton to see what works best for you. Also, should you wish to experiment with retouching solutions, inks, and other liquid media, using a brush is the preferred means of application.

A Faber Castell Peel-Off Magic Rub vinyl eraser is excellent for removing unwanted color. You erase it just as you would a pencil mark. Along with the eraser, you'll need canned air to blow the erasure particles off the print, the same way you would blow dust from a negative before printing in the darkroom. Don't use brushes to do this, because they can streak and otherwise damage the oil color on the print's surface.

Marshall manufactures two solutions for removing colors from prints: PMS (Prepared Medium Solution) and Marlene. I hardly use either because I find them messy and difficult to control, except when I need to remove all the oils from a print. To remove an entire application of color and start over again, you must repeatedly apply the solution with cotton balls until all the color is removed. When the cotton balls come up clean and there is no more color on the print, it must then dry before you begin working on it again. Avoid this process of removing colors with solution if possible; trust me, it is a time-consuming task that not many enjoy.

Compounds for Pretreating Prints. PMS is also used for pretreating, or precoating, prints to make their surfaces more receptive to coloring agents. Some papers, such as Ilford Multigrade FB, are better suited for handcoloring with photo oils and pencils after they've been pretreated with PMS. Agfa Portriga-Rapid paper is definitely more receptive to pencils when it is pretreated first. To pretreat a print with PMS, rub it into the photograph thoroughly and make sure that you remove all the excess solution completely. Any oil left on the print will probably become a messy problem as you work on the print later.

Should you wish to complete a print using only pencils, I strongly recommend that you pretreat the surface with PMS. Apply it lightly across the entire area with a cotton ball, and wipe it up with other cotton balls until all extra PMS is absorbed. This pretreatment interacts with the dry pencil "lead" to soften it and give it more the smooth characteristic of a photo oil. Without pretreatment, the colors on prints worked over with pencils appear a little crumbly or powdery.

Pretreatment of prints for handcoloring can't dramatically alter the receptivity of photographic papers to handcoloring; in other words, it can't transform a paper that isn't well suited to handcoloring into a perfect medium. Certain "precolor sprays" claim that they can do this. Their objective is to provide a working surface, or rough layer, on the photograph to which photo oils and pencils can adhere. I've found these sprays unsatisfactory.

There are two inherent problems with any spray pretreatment method. The first is that a spray is difficult to apply uniformly across a print; then color adheres to it unevenly. The second, and more serious, problem is that the sprayed application doesn't become part of the print surface but is only a layer floating on top of it. If the surface is rubbed, as it usually is during handcoloring, the layer of spray can separate from the print. If and when that happens, the image is lost. Because so many quality papers don't require this special treatment, I think there is little reason to employ this risky spraying method.

THE WORK AREA

For best results, you need an unblemished work surface that is smooth as glass. It could be Masonite, Plexiglas, heavy mat board, or the like; it should be larger in area than the print, of course, but not so large as to be unwieldy. Another option is to work directly on a perfectly smooth table or desk top. Keep in mind that the texture of whatever is below a piece of paper can be rubbed into it. Any scratches, lines, or other imperfections lying below the print can, during the coloring process, become indelibly etched into the print's surface. A grain of sand, for example, can cause irreparable harm to the print, literally breaking its surface and leaving a small tear that traps oil, creating a dark imperfection. Particularly on large expanses of single colors, such marks and lines are ruinous. Even cardboard that looks smooth shouldn't be used as a work board because underlying its surface is often a ribbed structure that will leave an impression on the print.

To affix a print to the work surface, use drafting tape rather than masking tape, because the latter sometimes adheres to prints and tears them, particularly fiber-based papers. Securely taping the print down makes it easier to handle and far more stable while you are working on its surface. Earlier, I strongly recommended printing photographs with borders for handcoloring; you attach the print to the working surface by taping it along its border, thereby leaving the image area clear. If you have a good eye and can accurately run the tape along the edge of the image and completely over the white border, you'll save yourself a lot of trouble when it is time to clean it up, as the tape will have protected the area beneath it from overlapping colors.

Whether you work on a drafting table, a desk, or an easel, position yourself so that a strong, even light illuminates your work surface without casting shadows. Because you'll be using a lot of oil-saturated cotton, keep a wastebasket handy for disposing it. Wearing old clothing or an apron is a good idea because you won't want stains of color to ruin good clothing.

Make your work area as comfortable as possible; you'll be spending long stretches of time there. I recommend that you finish handcoloring work in one sitting, which may require a few hours. If you take a break overnight, the oils will begin to "set" and then can't be worked the same way as when they were fresh. Then you may have to undo work you've already done, or you may not be able to correct imperfections. However, some handcolorists prefer to "layer" their work; that is, they allow one application of color to dry before adding another layer. Even if that is the case, the drying process needs to be completed between layers. Keep in mind that in the descriptions of basic handcoloring methods that follow, you are expected to finish the work at one sitting.

After the print is completed, leave it attached to the work surface for a couple of days until the oil dries. You'll want to avoid handling the print and accidentally smudging its surface because it is vulnerable to blemishing or smearing until it is completely dry. So be sure that your work area isn't in a heavy traffic pattern in your house or studio—hopefully, it is a quiet, secure place where you can leave your work undisturbed.

I work on a small, comfortable desk with a gooselamp attached for good lighting. Lying on my desk is a clean black-and-white photograph attached with drafting tape to an easel. A Deluxe Set of Marshall Photo Pencils and a Master Set of Marshall Photo-Oil Colors are ready and waiting, along with other supplies.

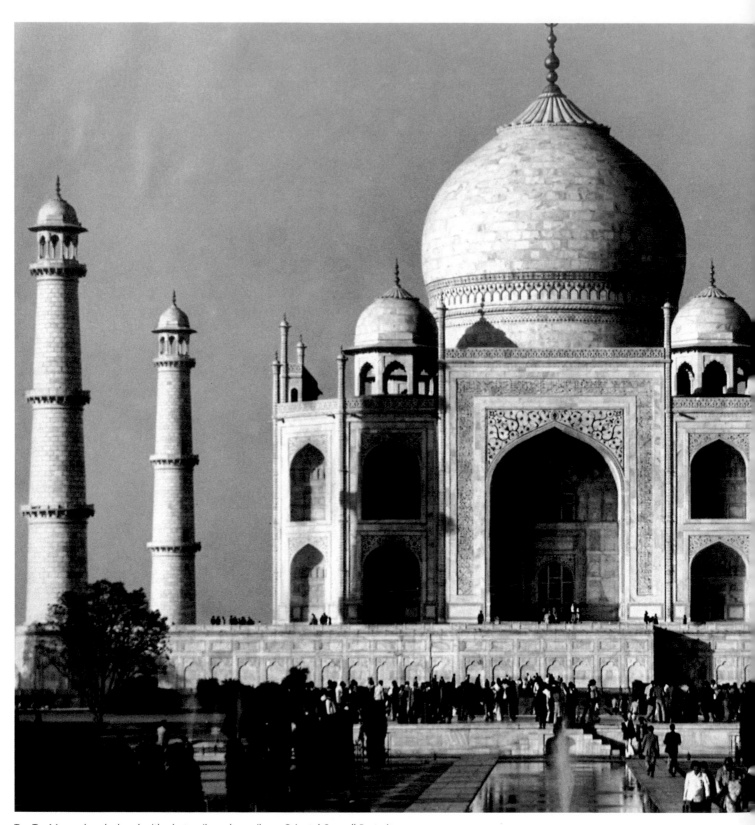

THE TAJ MAHAL, handcolored with photo oils and pencils on Oriental Seagull Portrait paper.

Basic Handcoloring Techniques

YOU'VE CHOSEN A PRINT; your photo oils, pencils and other materials are handy; and you're comfortably seated in a well-lit, quiet place. You are ready to begin. Plan to spend an uninterrupted two to three hours working on the print until it is finished. Drying time will take several days, depending on the humidity of your climate.

There are three distinct steps in my basic handcoloring method. The first I call the *wash*, which is a broad application of color that creates a color base across the entire print. *Detailing* is the next step, which includes correcting overlapping colors as well as shaping the print: adding shadows, depth, and highlights. When this step is complete, you're ready to *fine-tune* the image by adding, for example, subtle bits of color to eyes and cheeks or erasing stray colors. This last step is the final touch that takes care of the little but essential aspects of your art.

STEP ONE: THE WASH

The wash is common to all handcoloring techniques, from beginning to advanced, from pastel to intensely colored. It is really a simple procedure. The most important thing is to be patient, knowing that, at this stage, overlapping colors (or overruns) are inevitable. When you complete the wash, understand that your print will not only look unfinished, it will honestly look awful, nothing like what you had imagined or wanted your image to be. That's fine! After all, the wash is just the first step.

Rather than squeezing your photo oils onto a palette, I recommend applying them directly from the tube onto cotton swabs and then onto the print. Why? Because you don't want to waste the photo oil; this way, the unused oil stays in the tube and doesn't dry out before you use it. In each Marshall Photo-Oil kit, there is a nail-like device with a sharp point at one end, which is used to puncture a small opening at the top of the tube. As you are puncturing the tube, avoid squeezing it—you don't want to squirt photo oil all over your work area. After the tube is open, squeeze a moderate amount—really, just a small dab—onto the end of a cotton swab. After you've become comfortable with this—and if you are working a large area—you might want to use a cotton ball instead of a swab. Using a ball makes the wash faster but gives you less control along the borders of the color.

Now you apply the photo oil across the entire area you wish to color. There is no ironclad rule as to where to start. You might wish to start in the center and work outward, top to bottom, background to foreground, large area to small. The object of the wash is to spread an even layer of color over the entire area you are coloring. When you've finished coloring one area, take a fresh cotton ball

I squeeze photo oil straight from the tube onto a cotton swab, one of the best tools for applying color directly onto the print.

and work it across the area you've just colored. The object is to even out the application and absorb all excess photo oil. No matter how intense you want the color ultimately to be, at this point you must work toward achieving a smooth, light application of color. It will appear flat. Don't worry—more color can be applied to intensify it later.

Working with pencils alters the wash somewhat, in that you can apply color with a pencil a bit more accurately; hence, you have fewer overruns. Photo oils require more absorbing with cotton balls, more working into the print. I use the tops of cotton swabs to blend pencil color, but I use cotton balls for photo oils.

Perhaps the hardest part of doing the wash is learning to overlap colors at their borders. That's right—*don't stop at the color's border, rub right through it into the next color area.* This is where beginners make the most mistakes. Their overwhelming tendency is to work right up to the edge of the color and stop. What happens is that excess oil then builds up at the edges, separating colors, which is a mistake that causes many subsequent problems. First, your color application will appear heavier at the edges and look uneven, an aesthetic flaw. Second, colors will mix together where the excess oils are, again leading to unwanted results.

Okay, you've bitten your tongue and followed my advice. You're not pleased that your subject's flesh tones run down her blouse and into the background. Pay no attention to these irritations; just repeat the wash process with the next color. Watch what happens to the overlapping areas of the previous color as you apply the new color over it. Notice how the new application replaces, or "lifts," the former color—it doesn't blend in, it just disappears.

The way one application of color lifts another is practically magic, part of why I say photo oils are so "forgiving." This is also why overlapping colors shouldn't worry you. Only in some cases of a strong color being applied first—for example, Viridian Green or Extra-Strong Cadmium Yellow—might it mix somewhat with a new color laid over it. If that happens, take a second fresh swab, apply the desired color, and go back over the same area. This should lift any mixed color. When you rub down the new color, you are again likely to overlap colors somewhat at their borders. Yet you must always go through with the rubbing procedure so that you don't build up excess oil. You will be able to take care of the overlap soon, in the detailing phase.

Keep repeating the process of applying base colors to each area you wish colored until the print is completely tinted. At this point, you shouldn't be interested, for

example, in coloring eyes or lips in a portrait but simply in applying a uniform flesh tone across the face and neck. It is easy to understand the temptation to interrupt this process in order to start adding details prematurely. Beginners do this all the time, ignoring instructions to complete the wash despite its appearance. Yet, think about it. You've seen how one color will always lift the one underneath it. Why work on details, only to have them lifted by a subsequent color application?

A second key word to introduce here is *practice*. While some beginners I've taught have actually entered their first handcolored efforts in competitions and won or placed, this method requires familiarity for you to become comfortable and confident, and that comes from practice. Then you know how the process works, what to expect at a given time, how to make the applications more uniform and effective. And you become adept at working the borders between colors, so eventually there is less overlap there, while at the same time you don't violate the primary rules governing the wash. Whether you enjoy working

with scenics, people, or still lifes, the wash step is common to each. As you become experienced, you will go right through it without questioning how the image looks at this point.

The kind of paper you're using will affect how the wash looks when it's done. If the surface of the print is hard and glossy, very little color will be apparent. On the other hand, an absorbent paper will show a significant color effect, although it will seem excessively flat.

How do you evaluate a finished wash? Hold the print at an angle to the light and look at the surface. There should be a subtle shine across the areas where you applied photo oil, probably over the whole print. This shine should appear even. If there are any areas where the shine is brighter, particularly along borders between colors, this reveals a buildup of excess oils. If you see this, take a cotton ball and rub both sides of the border along its line. This will keep the excess oils from mixing too much and should alleviate the problem. Work at the border until the excess is absorbed. Step one is now complete.

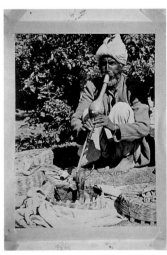

I begin by taping my black-and-white print with drafting tape onto a mat-board easel.

Here I'm rubbing down a color with a cotton ball to remove excess photo oil.

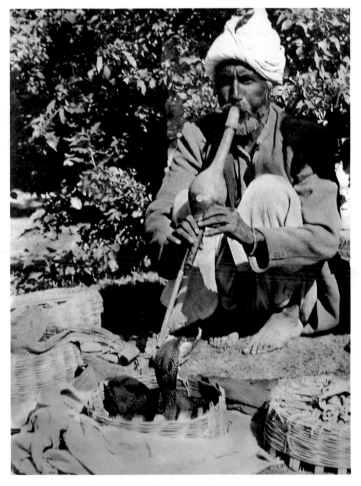

This is how the picture looks when the wash stage is complete. Notice how the colors overlap and how flat they look; this is okay.

STEP TWO: DETAILING

Detailing is the stage of handcoloring in which the essence of the print begins to emerge. The wash has been completed, so the print is colored; yet it has no vitality, no real distinction. Where the wash stage left the print looking flat, the detailing phase will shape it. A lot of change occurs during detailing, and various areas of the print will vie for your attention. Nonetheless, you should still be looking at the entire composition, and at how colors and contrasts are working together, not at elements in isolation as you will in the next step when you fine-tune the picture.

In detailing, your first task is to remove any overlapping colors. You know that applying a second color over the first layer will lift it, so you simply go back with the desired color and lift the overlap. This might require doing a second lift if very intense colors, such as Viridian or Vermillion, were used. Be careful to blend the new application into the existing base so that the lift occurs evenly.

Take a new cotton swab and rub in some photo oil, making sure that the oil penetrates the surface of the swab. Your objective is to use this swab with more control than during the wash. Absorbing the overlap and merging the new color application with the existing color requires a delicate touch and lots of practice to do effectively. Crush the oil directly into the tip of the new swab—this will ensure that you don't apply a heavy glob of new color. You want it to be light because it needs to combine with the base that was previously rubbed down during the wash.

The real test in detailing is to blend the second application of color smoothly into the original color wash. Your eyes will judge how effectively you do this. A helpful tip is to use the clean end of the cotton swab like a miniature cotton ball to absorb excess color. This takes a very light touch, as clean cotton is very absorbant and could remove more color than you want, leaving a lighter spot in the surrounding color. Blending the color in isn't really a difficult process, just a matter of practice until your touch becomes expert, and you know how to manipulate and "feather" the application so that it blends gradually. Repeat this process until you've cleaned up all overlapping areas.

After you've cleaned the borders, you are ready to add depth to the image by shaping the objects in it. Begin with the shadow areas. They show through the wash as darker areas of the photograph that look unnatural now due to the color overlay. Standard procedure is to take Neutral Tint photo oil, crush a small bit into a swab, and apply it into the darkest part of a shadow first, feathering it outward. Don't use a big glob of Neutral Tint; a small amount is best. You'll have to reapply the color several times and change swabs once in a while, but working this way is easier and more effective.

One characteristic of Neutral Tint is that in dark areas it blends into the color over which you apply it, even though it looks gray when it comes out of the tube (Neutral Tint is not meant to be used as a gray, although it can be). For example, if you are working on a dark shadow area that has been colored Vermillion, the Neutral Tint tends to become a deep vermillion color, as opposed to lifting the Vermillion and imposing a separate gray. However, you may have to blend some of the base color into the lighter portions of a shadow feathered by Neutral Tint so that the base color doesn't become too gray.

For detailing, I rely on photo oils. However, you could use photo pencils in much the same manner, although I don't think pencils lift colors as well as photo oils do. With practice, you might be able to achieve the same illusion using pencils, but much more finesse and skill is required. Design Spectracolor pencils include numerous earth tones, flesh colors, and neutral grays that are effective for working on shadows.

When you've finished creating shadows, turn your attention to the picture's highlights, or very light areas. Extreme highlights look white naturally and should stay almost devoid of color. To remove the wash over them, take a fresh swab and rub out the color, working outward from the highlight's center. Graduate the color's disappearance inside the highlight so that you don't create an abrupt border between a bright white void and the rest of the color.

A third aspect of detailing is restoring color to areas of the picture that were rubbed down during the wash but that require greater color impact. For example, in a landscape, the sky is never an even blue from the horizon up to the heavens; the blue becomes more intense as you look up. You can create this effect in a handcolored photograph by taking the same cotton ball you used to absorb the blue during the wash phase (if it hasn't been contaminated by another color) and lightly rubbing it onto the print where you want more color. For small areas, use a cotton swab with color crushed into the tip. Keep in mind that working with a cotton ball is more advantageous because its color application is less intense and more gradual, and covers a larger area without streaking.

If you need to use a clean new cotton swab or ball for blending the new application into the base color, always rub some color into it first. You can do this by squeezing a dab of color onto a paper towel, for example, and rubbing the ball or swab over it. Don't let the color be absorbed by just a small piece of the ball; saturate its entire surface. It is important that you remember not to use perfectly clean cotton at this stage; it is too absorbant and will actually remove the color that you're adding.

Finally, you might want to blend in a new color gradually over the color wash. Depending on your objective, there are several ways to do this. If you don't want the second color to lift the first and remove it, proceed as follows: Take a cotton swab, put a small dab of the base color on it, and crush the color into the tip by pinching it with a paper towel as just described. Then put a dab of the new color on the swab and repeat the crushing process. Now, begin with an area of the print where you want maximum effect from the new color and work the blended colors onto it lightly towards the area where the two colors should blend and the base color should dominate.

If you want the new color to look pure and replace the color wash—for example, adding a yellow area to an otherwise blue sky—put a dab of the new color on a swab and apply it carefully, beginning in the area that you want to be pure new color and moving outward in all directions. The base color will lift in the area of maximum saturation of the new color, and then there will be a gradual blend back toward the base color. Blending colors takes practice, yet produces a beautifully subtle, graded shift between colors.

To clean the borders between colors, I take a fresh cotton swab, squeeze on the color I want the area to remain, and use this to lift other colors overrunning into that area.

Neutral Tint is applied to shadow areas to correct their color and make them look more realistic.

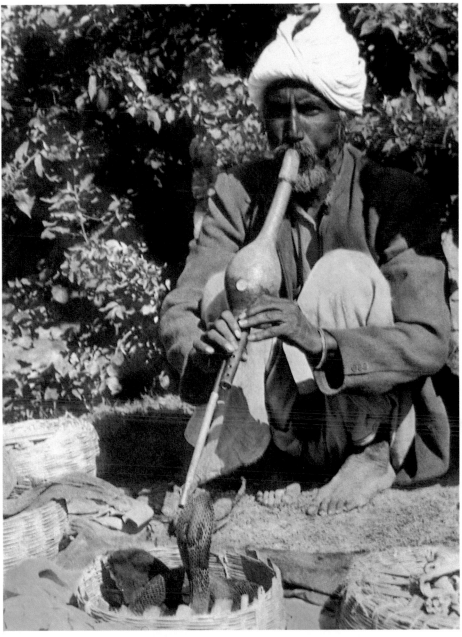

When the detailing phase is complete, the borders between colors have been cleaned, and shadows and highlights are clearer; however, the picture still looks unfinished.

STEP THREE: FINE-TUNING

As my method of handcoloring became more defined, primarily through the workshops and demonstrations I was conducting on the subject, I became aware that some of the most dramatic changes in the handcoloring process occur during the final few minutes of work on any given image. Because so little has been published on the subject for so long, I felt compelled to come up with a term for this final stage of my procedure, and I chose "fine-tuning." This may sound mechanical, but that too is appropriate, as this stage is similar to tuning in a radio or television station—what moments earlier was a static mess suddenly becomes very clear. Hence, I co-opted the term and continue to use it.

Fine-tuning a handcolored photograph involves any uncompleted work after you've finished the detailing stage. In essence, fine-tuning means addressing the very small details. The difference between it and detailing is that in the latter your perspective should include the entire photograph—its shapes, depth, shadows, and highlights. In fine-tuning you are focusing on individual components that make up the composition. For example, fine-tuning a portrait means that the eyes, lips, highlights in the hair, jewelry, and accessories become the focus of your attention. For a car, you would focus on the chrome, the taillights, logos, and lettering. If there were a sign in the background, you would now focus on the lettering.

Let's go back to fine-tuning a portrait. After you've shaped, shadowed, and highlighted the face, there will still be flesh tones running across the eyes and teeth, and probably unwanted color across the accessories your subject is wearing. In fact, the picture should look far from finished. This is where fine-tuning begins. First, using your vinyl eraser, carefully remove all unwanted color from the eyes, lips, and teeth. The whites of the eyes usually should stay pure white. To color the irises, take either a colored pencil or a toothpick with a small cotton swab twisted onto one end and carefully apply Verona Brown, Ultra Blue, Viridian, or Tree Green—whatever color you want your subject's eyes to be. With another toothpick swab or photo pencil, add color to the lips—Lip, Lipstick Red, or Carmine for a woman, a light touch of Cheek for a man (see the color charts for Marshall Photo-Oils on pages 40 and 42).

Little touches of color produce dramatic results. You'll be astonished by the change you now see in the image because it will be completely out of proportion to the amount of work involved. If there is jewelry or accessories to fine-tune, simply erase the overlying color to create the look of silver; adding Raw Sienna will create a golden effect. You might look at the hair and decide to add Burnt Sienna to the extreme highlights of a brown-haired subject or Cadmium Yellow to a blond. These are just suggestions; you'll come up with your own ideas.

As for landscapes, remember that trees are dappled colors rather than a uniform green. Creating shadows with Neutral Tint brought out broad shapes; now it is time to add some touches of Cadmium Yellow Deep to a few highlighted leaves, some additional Tree or Oxide Green to other lighter clusters of leaves, and a few lines of Verona Brown to some branches. Fine-tuning foliage in this manner increases its impression of fullness and vitality.

It is impossible to describe or anticipate what will constitute fine-tuning for every type of handcoloring. The French have a saying that goes, roughly, "the more things change, the more they stay the same." The same can be said of the fine-tuning stage. Although the image seems to leap to life afterward, the overall effect remains the same. While I can't guess what your images will look like, I feel confident I can predict your amazement when you see the effect of fine-tuning on your work.

Fine-tuning doesn't mean perfecting an image, but it means creating an impression of completeness. Where traditional handcolorists sought to replicate reality, today handcolorists manipulate and revisualize it. Colors no longer have to be perfect, but they should work for your vision. I'm not suggesting that you leave a work unfinished or that you work carelessly; however, there is a point when you've completed the work by providing enough nuances to create the right impression. Continuing to rework areas because you think you should create a reality that can't possibly be achieved is what I am cautioning against. Sometimes the best work is accomplished by knowing when to call the image finished. I could have spent days trying to add more details to the people in the Taj Mahal photograph, but I would have accomplished nothing. Handcoloring experience teaches that less is more. Work toward your own satisfaction, and know when to let go.

Removing and Drying the Print. Speaking of letting go, here are a few words about what to do when the print is finished. If you've taped it to a working surface by running tape along the entire border, be careful as you now remove it. With a thumb on the corner of the print, hold it down as you strip off the tape so that the print doesn't pull against the remaining tape and tear there. Repeat the process until you have removed the tape from all four sides. Now I suggest taping the corners to the work surface so that the print remains attached to something flat while it dries.

There might be a small dark line running where the edge of the tape used to be; this is really a small, unavoidable buildup of photo oil in the little recess that existed between the print and the tape. Take a clean swab and carefully rub along the line to reduce it without intruding into the photograph. Then, using your vinyl

eraser and again exercising great care, rub the eraser along the line. The goal is to remove the buildup without messing up the edge of the print.

If you originally taped only the corners of the print, now there is a lot of photo oil smeared in the white borders. Carefully erase the smears with the vinyl eraser. If there is a really heavy oil smear, take a swab and absorb the excess first, then erase the remaining oil. Carefully blow away all the erasure particles with canned air, as you don't want them sticking to the print.

Congratulations—you've now finished a handcolored photograph. Set the print aside to dry in a dust-free environment if possible. The former owners of the studio I bought would tack a print to a wall or vertical surface and then tack a sheet of plastic food wrap above the print so that the plastic fell like a curtain in front of it without pressing against it. This method of protecting the print from dust works quite well, but make sure that the plastic doesn't stick to the print's surface.

The print should dry in a few days, depending on humidity and the nature of the tint. A heavier oil application, such as the handpainted images described on page 67, will take much longer. Once a print is dry, you can further protect its surface with a matte spray, such as Marshall's Matte Finish Spray. If you wish to frame it, either tape the print to the backing or spray-mount it. I don't recommend heat mounting, as it can damage handcolored prints.

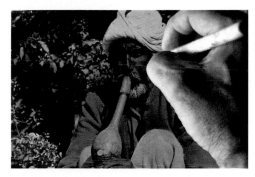

Using my Magic Rub vinyl eraser, I remove color from my subject's beard.

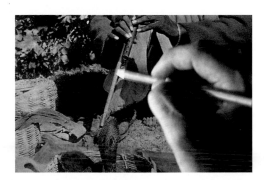

Here I intensify the color of a long, thin detail using a photo pencil for precision.

The man's turban looks better after I add more yellow with a cotton swab.

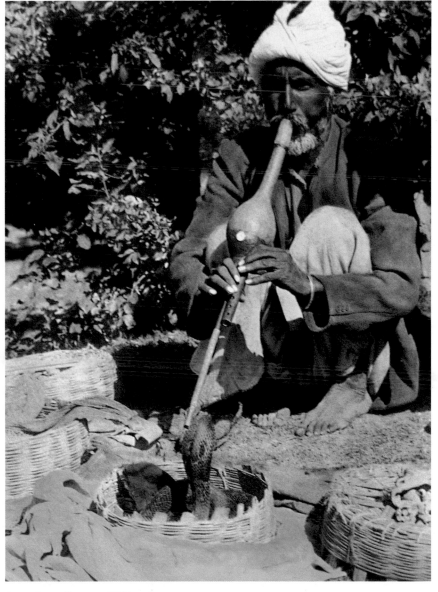

INDIAN SNAKE CHARMER, 1979
Fine-tuning the details results in a finished portrait.

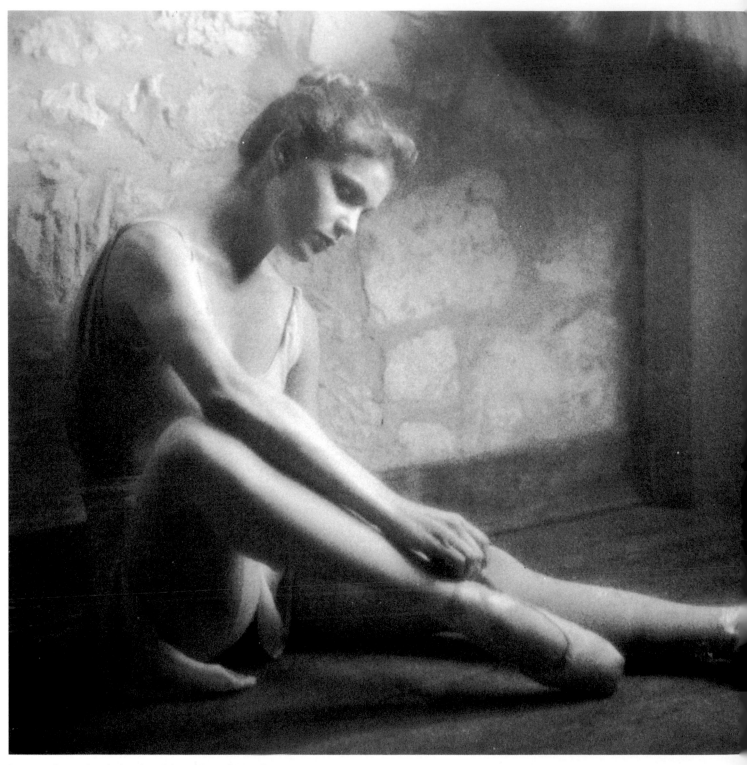

DANCER IN STUDIO, handcolored on Oriental Seagull Portrait paper.

Ways to Approach Various Subjects

ALTHOUGH REALISM isn't a high priority for many contemporary handcolorists, familiar subjects often warrant a realistic approach. Matching someone's skin color perfectly with a photo oil may not be necessary, but most viewers would be uncomfortable with a portrait rendered in deathlike bluish flesh tones. The same goes for landscapes; personally, I like seeing a rich interplay of light, color, and shadows using various colors, not just a uniform Tree Green. What follows are some general guidelines for effectively coloring common categories of subjects—people, outdoor scenes, and still lifes. Of course, these suggestions should be used as points of departure for your own creative interpretations.

PEOPLE

Rather than limit this to portraits, this category refers to photographs in which people are the primary subject. This can include informal photographs, model portfolios, commercial and fashion shots, nudes and other art images, and even popular "boudoir" portraits, as well as traditional head and shoulder portraits.

In any picture of people, strong emphasis is put on flesh tones, as well as hair and clothing. The Marshall Master Photo-Oils kit offers a range of flesh tones, including a Flesh Shadow for facial shadows. Also, I find that using a fresh cotton swab with plain Flesh rubbed into it can be lightly reapplied to the shadow areas as an effective substitute. As mentioned earlier, either brown or sepia toning creates a print with a warmer base for more realistic flesh tones. Compare toned and untoned photographs of an identical picture to decide whether toning is an approach you want to take.

Many ethnic and racial skin tones aren't covered by the special photo oils Marshall has developed for Caucasian skin tones. Darker Native American and Hispanic tones can be achieved by adding such earth tones as Burnt Sienna

to either one of the Flesh tones or to Verona Brown. The base color could be Burnt Sienna, with Verona Brown worked into the shadows, with Flesh, Cheek, or a blend of these worked into facial highlights. Black skin tones are varied; generally, I start with a base of Verona Brown and work Burnt Sienna into the highlights. In some cases, mixing in Raw Sienna is a good idea, and Sepia can be substituted for Verona Brown in deep shadows or darker Black skin tones. Polynesian and Oriental skin tones might require a combination of Raw Sienna and Flesh for the best rendition. You'll discover how to create more subtle variations in skin color as you experiment.

After you've determined which skin-tone combination works for your subject, the three-step handcoloring technique described in the last section still applies. Usually, I apply background color first, then color the clothing and finally the skin tones, but that isn't an ironclad rule; many practical exceptions are dictated by circumstance. Your dominant shade becomes the "wash" base, and you blend in additional shades as you detail and fine-tune the print. When adding a second color, work

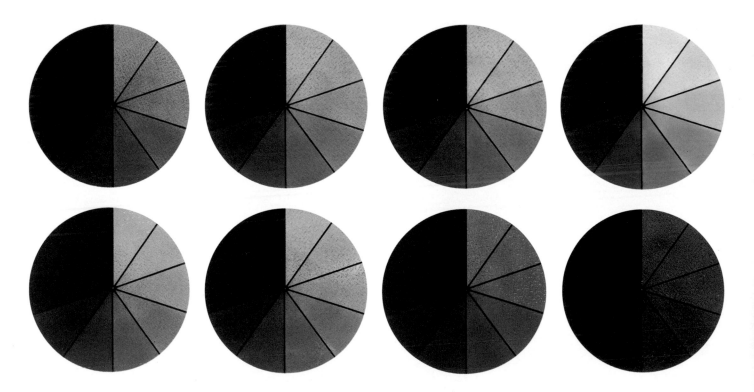

Earth tones can be blended with other colors to achieve a variety of skin tones, and hair and eye colors. Eight Marshall Photo-Oil earth tones are available, applied here over wheels that show how the colors are affected by print contrast, from left to right. Top row: Sepia, Verona Brown, Burnt Sienna, and Raw Sienna. Bottom row: Khaki, Neutral Tint, Payne's Gray, and Grayed Background Blue.

from the point of maximum effect towards the edges, being careful to achieve a blend as opposed to lifting the color base. Remember to blend the two shades together into a cotton swab if you find lifting to be a problem.

Here is a tip for women's portraits: Blend Cheek into the areas of her face where she is likely to be wearing makeup, in order to give her face a rosy glow. I find it best to take a cotton swab that has Flesh crushed into it and add Cheek to it, crushing it in. You don't want the Cheek to lift the Flesh, but to blend gradually and add a natural rosy tint to the face.

This is not a primer on traditional handcoloring, so I'm not going to dwell on portrait techniques. With the above information and my basic handcoloring method, you should be able to develop your own approach to handcoloring people's skin tones. Let me remind you not to become too focused on detail; "less is more," and this applies to portraiture as well.

Hair coloring is also important. Blond hair is easy to create by applying Raw Sienna to the highlights and Verona Brown to the shadows. Brown hair can be achieved with either Verona Brown or the darker Sepia. Neutral Tint works well for black hair, and Burnt Sienna for Redheads. A lot of this is a subjective call on the artist's part. If you want to add highlights to the hair, do it during the fine-tuning stage.

SUNDAY MORNING OFF BOURBON STREET, handcolored on Forte Elegance Bromofort paper.

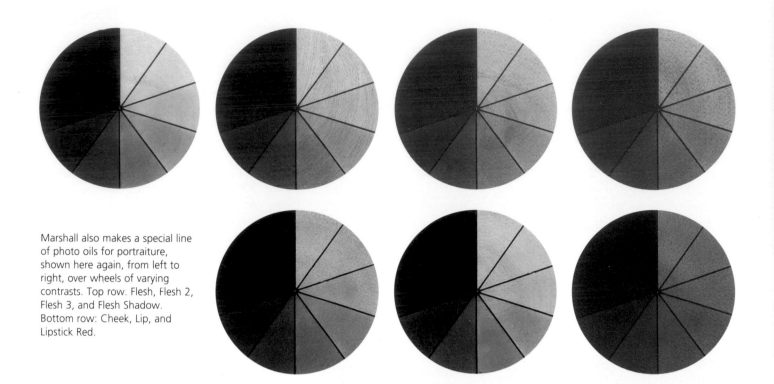

Marshall also makes a special line of photo oils for portraiture, shown here again, from left to right, over wheels of varying contrasts. Top row. Flesh, Flesh 2, Flesh 3, and Flesh Shadow. Bottom row: Cheek, Lip, and Lipstick Red.

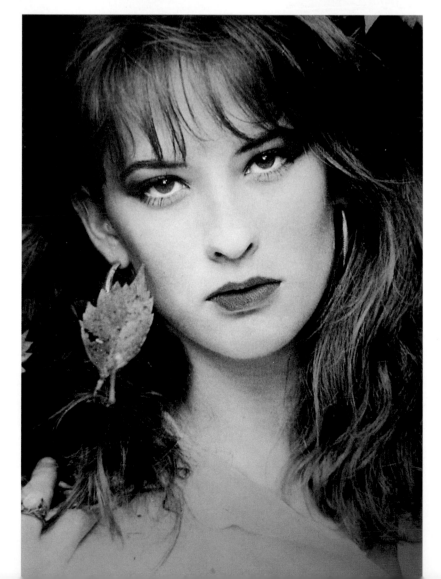

STACI, handcolored on Forte Elegance Bromofort paper.

OUTDOOR SCENES

This category includes landscapes, urban scenes, architectural images, scenics, and seascapes. Obviously, this list is incomplete. The idea is that outdoor scenes aren't primarily about people but are sufficiently interesting to be photographed in the first place. There is a wonderful variety of outdoor scenes by different artists in the gallery in Part II, including humorous scenes, haunting desert vistas, and abstract compositions.

Handcoloring outdoor scenes follows the established procedure: a wash, detailing, and fine-tuning. You might decide that the sky should be Sky Blue, or you might color it in wild shades of Vermillion, Cadmium Yellow Deep, and Cobalt Violet. Not only does how the sky looks vary with the time of day, it depends on your imagination. Water can be colored Viridian, Payne's Gray, Ultra Blue, or a mix that you create. Reflections are important; think about the landscape's colors surrounding the water and recreate them in the water in abstract patterns.

As mentioned earlier, in landscapes trees aren't just Tree Green, they include dark shadows, browns, brighter greens and even sunlight reflecting off leaves. Adding shadows gives any outdoor scene greater authenticity, whether you use Neutral tint or a subtle shade of violet or blue. Mountains might be blue or purple, gray or reddish brown, depending on the light, distance, and effect you want. Weathered wood might be colored with Neutral Tint or a light application of Verona Brown. Fields might be Oxide Green in spring and Raw Sienna in the fall, but they are most likely a combination of colors.

Backgrounds are usually best rendered in subtle colors and with softened borders. Sometimes you'll want to add such individual details as reeds or blades of grass with photo pencils for emphasis. Remember that you're not after accuracy but impression. When do you add these colors? Usually when you are fine-tuning, as final touches are what make outdoor scenes really work.

I handcolored this lovely, pastoral scene on Oriental Seagull Portrait paper.

STILL LIFES

A loaf of bread, a jug of wine, and a bowl of fruit are traditional still-life subjects, but many less orthodox ones are just as suitable. For example, the gallery section in Part II of this book contains some magnificent, surprising still lifes of subjects you might not immediately consider for handcoloring. Flowers, of course, make excellent subjects, not only for their beautiful colors but also their shapes and potential for composition. Lace and jewelry, and trinkets on a tabletop are also popular still-life subjects, but so, apparently, is Godzilla! (See page 96.) Still-life photographs provide wide-open vistas for creative handcoloring work, encouraging effects that set images of inanimate subjects quite apart from what we ordinarily expect to see.

Still lifes offer a great opportunity to work with pure color, perhaps more so than other subject matter does.

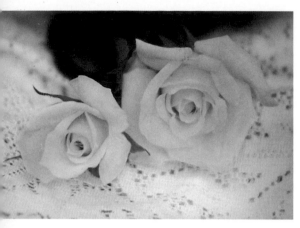

Roses for Mother, handcolored on Agfa Portriga-Rapid 118 paper.

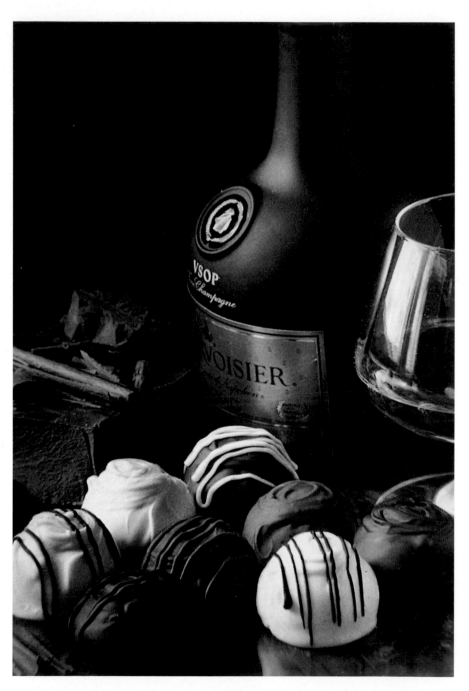

Cognac and Chocolate, handcolored on Luminos RC Pastel Ivory paper.

In portraits, we usually make assumptions about the colors that our subjects' skin and facial features should be. Because there is less to assume when viewing still lifes, they give our imagination more latitude, more freedom to exercise our art. For example, the pearlescent glow on the glass of a vase makes a perfect canvas for a multitude of colors. A flower's petals could be made into a rainbow of shadow and color with simple shading variations. Or pure, unadulterated color could make a red racing car scream for attention.

From a procedural standpoint, the sequence for handcoloring still lifes remains the same as for other subjects. You choose colors for the wash, you add shadows and shaping during the detailing phase, and you complete the print by fine-tuning the details. To color the intricate details, for example, of a china pattern, you might decide to work mainly with pencils. The individual artists in Part II provide more information about how they colored specific still lifes and why they chose certain palettes for certain subjects.

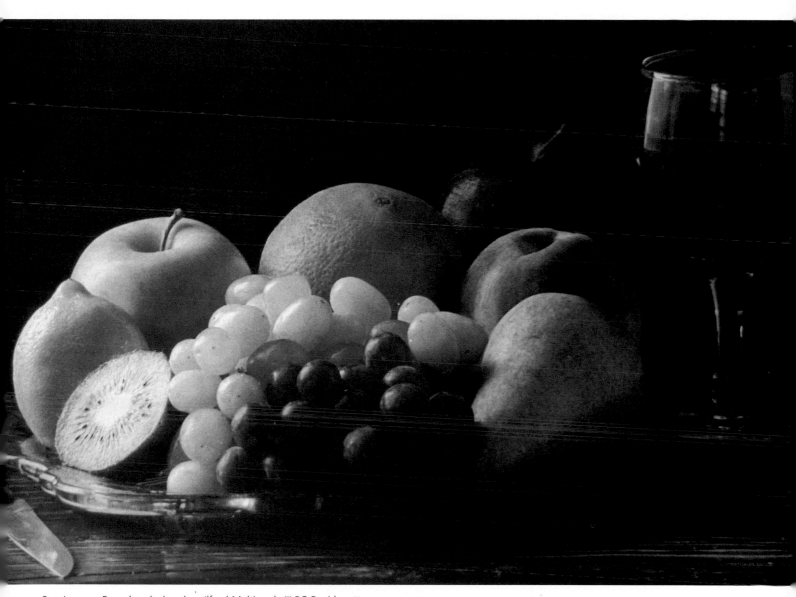

STILL LIFE WITH FRUIT, handcolored on Ilford Multigrade III RC Rapid matte paper.

Once Upon a Time at the Y-O, handcolored on Agfa Portriga-Rapid paper.

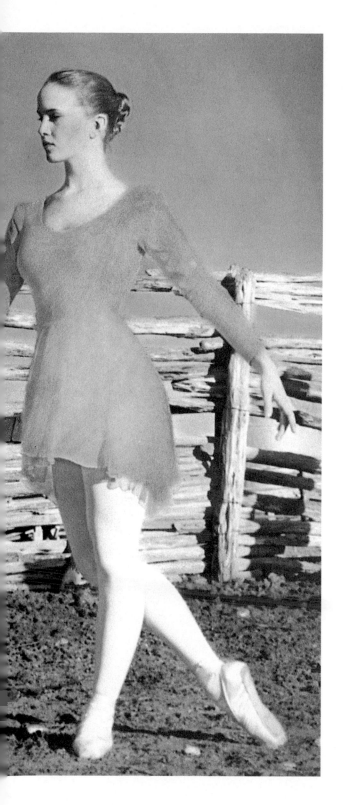

Special Handcoloring Techniques

AT SOME POINT in your handcoloring, you'll begin to invent a world of your own. Color begins to be important for its own sake. This section of the book explores two extremes of color that I call minimal color and ultracolor. The first is such a subtle, ephemeral tinting of a photograph that the viewer's imagination is engaged in filling out the image. At the opposite end of the spectrum is ultracolor, a garish, exaggerated palette with which to experiment for bold handcoloring effects. Now that you've learned the basic techniques, have some fun and give these a try.

MINIMAL COLOR

The primary difference between basic handcoloring and minimal color lies in the results. Literally minimal, very faint and subtle, minimal color is intentional and not simply the result of trying to color a photographic paper that doesn't respond well to handcoloring. Minimal color is often pastel, although its color effect can be even lighter, and is best when matched with an appropriate subject. For example, in the case of "Limbering," (opposite page) the dancers were in such an ascetic environment that it seemed almost devoid of color, so using minimal color was a perfect approach. It seems well suited for many fine-art purposes. Basically, minimal colors chosen are subtle,

intentional, downplayed in certain situations, and often used only for emphasis in juxtaposition with the black-and-white image. Minimal color can be so subtle that viewers are unaware that a print has been handcolored.

The difference in the basic handcoloring technique involved in minimal color is best described in terms of a reduced intensity of color application right from the start. One way to achieve this would be vigilantly rubbing a color down with clean cotton balls; however, this way you might accidentally damage the surface of the print by abrading it, particularly if you apply too much pressure. On the other hand, if you reduce the intensity of the color

CALLA LILY 1, handcolored on Ilford Multigrade FB paper.

applied, you can achieve a minimal color effect naturally using the same procedure previously outlined.

The way to reduce a color's intensity when you apply it is to mix a blend of the color with Marshall's Extender on a palette or dish *away from the print*. Marshall's Extender is a clear gel that mixes easily with photo oils. Experiment to find the right proportions for the color you want, beginning with a 1:1 mixture and testing the results. You must mix the Extender and the oil thoroughly prior to applying it to the print; otherwise, pure Extender will lift color off of the print.

For minimal color, follow the basic handcoloring techniques: apply the mix to the print, rub it down, and complete the wash stage as normal. Remember that you don't have to apply a wash of color across the entire print. Especially when you're working with minimal color, leaving parts of the print in black and white is an excellent strategy for focusing the viewer on what you do color. Continue to mix Extender in with the colors that you apply during the detailing and fine-tuning stages, adjusting the ratio of the mixture to suit your purposes.

Marshall's Extender is a deceptive agent because it is so effective. For example, you might see too much reduction in your color's intensity and be reluctant to rub it down enough when you need to even out the color application and absorb excess oils. But if the Extender mixture remains on the print, it can be lethal to the final image because it will create a messy situation later on. If you think you've reduced the color too much, you can reapply more color right onto the print; it should blend easily into the previous mixed application. Adding pure color will increase the minimal color effect somewhat but won't restore it to the intensity of the "unextended" color.

It is wise to handle Marshall's Extender with care. The fact that it is colorless, and that only a small amount can smear and lift an already applied color, may cause you unwanted grief. Accidentally getting some on your hands and not wiping it off completely can lead to your transferring some onto a print; and unlike a smear of photo oil that you can see and remove, you'll probably overlook the unwanted addition of Extender until it is too late.

Another technique for downplaying color in the print is to apply either Neutral Tint or Ivory Black onto uncolored shadows, and conversely Titanium White onto the naked highlights. For example, you might choose this method for coloring a print with little subject matter to color, such as in "Calla Lily 1" (left), in which only small amounts of Cadmium Yellow and Oxide Green were used, while the black-and-white portions of the photograph were intensified with Ivory Black and Titanium White. Although this method differs from using Extender to reduce color effect, the outcome has a similar visual impact.

A variation of the above method of selecting a print with limited need for color is to restrict the application of color regardless of the print's characteristics. "Woman on the Beach" (page 50) is an excellent example. I finished handcoloring this print in just a few minutes, restricting the color to a light application of Flesh, Raw Sienna for her hair, and Tree Green along the horizon. Viewers react strongly to this print, yet the colors are so "impressionistic," so simple.

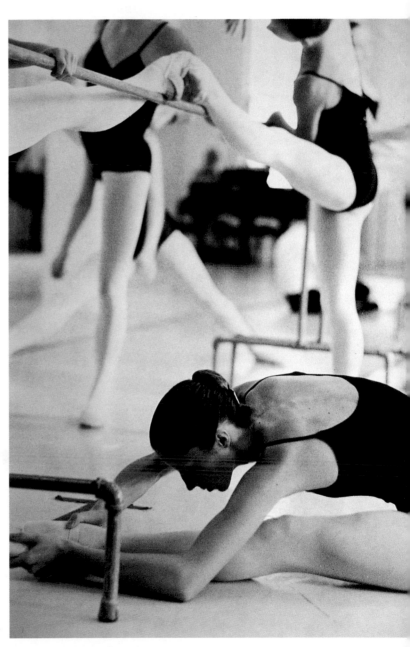

LIMBERING, handcolored using Marshall's Extender on Agfa Portriga-Rapid paper.

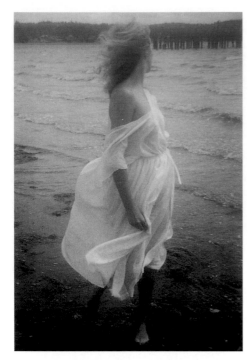

I photographed this scene on color film (above) but also printed a black-and-white photograph from the negative and toned the print brown. On this I handcolored only her face, arms, legs, and hair, as well as the tree line. Because I think this is one of those "less is more" situations, I like the minimal-colored version better than the original color photograph. Which do you prefer?

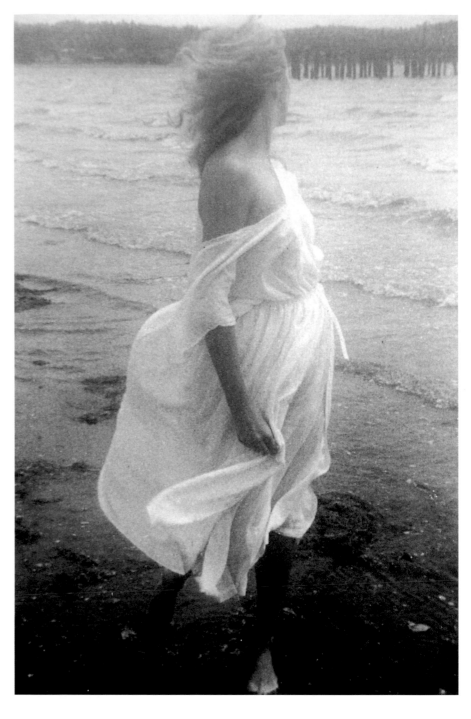

WOMAN ON THE BEACH, handcolored on Agfa Portriga-Rapid paper.

Many floral photographs, dance photographs, "vintage-looking" images, and images that are romantic and sensual respond well to a minimal color treatment. Also, you can direct a viewer's focus within an image by restricting the color you apply. So the term "minimal color" covers a reasonably varied spectrum of ways to manipulate a handcolored image. Look through your portfolio to see whether you already have photographs that would lend themselves to this technique. Also, you

might begin to visualize situations where you'll want to use limited color to complete the work.

The terms I've used to describe minimal color are ones that I've coined, but other handcolorists may use different terminology when discussing similar effects. In Part II, I hope you'll enjoy comparing how some have achieved similar results with the techniques I've presented here, as well as how and why they selected images for what I call minimal color.

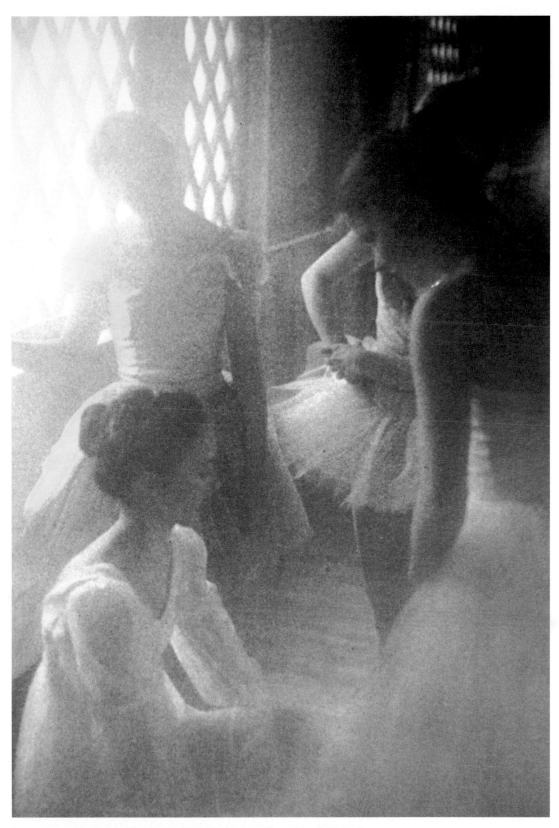

To create pastel colors harmonious with the soft, romantic nature of this backstage scene, I used Marshall's Extender to handcolor the ballerinas' dresses.

ULTRACOLOR

Ultracolor is bright, garish, attention-grabbing, and offends most "purists" because it isn't what most people think of when they think of handcoloring. Ultracolor is another self-coined term and was inspired by Agfa's advertising agency. Explaining why they chose my image, "Girl on Couch," over other handcolored pieces for their 1985 advertising campaign, Agfa said that, while the other pictures were good, they were "too realistic," and that viewers of their ad might not realize those images were handcolored. On the other hand, Agfa said that "Girl on Couch" had stopping power, and that people would realize that its color was more than natural. Agfa's response to my work led me to view ultracolor as a whole new field within handcoloring, and it has become my specialty.

Ultracolor has much in common with the basic handcoloring method, as it requires a wash phase before you detail and then fine-tune the image. Don't try to shortcut the process. During the wash, because your anticipated end result is brilliant color, you may be tempted not to absorb enough color when you rub down the application to ensure that the color base is smooth and blemish-free. If you don't complete the wash as described earlier, you'll end up with a mess of colors blending together later on—not the ultracolor effect.

Because you want the strongest color effect possible, the paper you choose is critical. The most absorbant papers permit the greatest color saturation, and the best for ultracolor are Agfa Portriga-Rapid 118, Forte Elegance Bromofort and Fortezo, and the Luminos papers—

Toned brown.

Handcolored using my basic method and a basic palette.

Charcoal and Tapestry. For the most powerful ultracolor effect, choose one of these papers.

Another suggestion is to use Marshall Extra-Strong colors whenever possible. Not all Marshall Photo-Oil sets include a choice of intensities, but many, such as Marshall's Master Set, do. You may also find that, occasionally, adding a small amount of Titanium White to your desired color will punch up its intensity. However, experiment carefully with this before applying the color, as the blend could change a color's tone, for example, from Carmine to a hot pink. Blending colors also makes them slightly more opaque, a quality that might obscure details in the underlying photograph. However, if you want to create a "hot tropical" look with pink, turquoise, peach, and light purple, you might like to experiment with this technique (see the color chart on page 57 for examples of mixed colors). Don't hesitate to try your own blends; just keep notes for future reference.

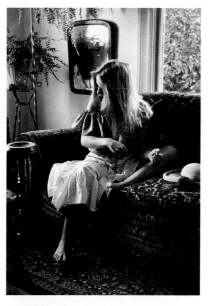

To illustrate how many kinds of images a single negative can yield, I manipulated this black-and-white print (left) four ways. First, I just toned it brown, then I handcolored it using my basic method and a basic palette, then I handcolored it with minimal color, and finally I rendered it in ultracolor.

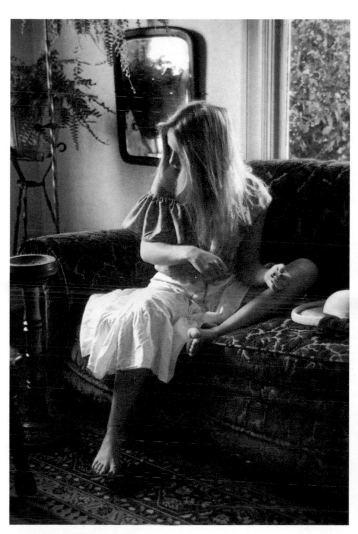

Handcolored with minimal color.

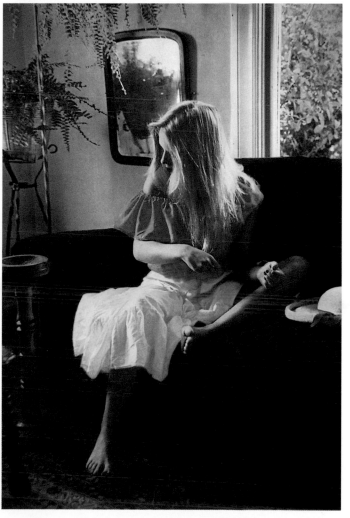

GIRL ON COUCH, ultracolored on Agfa Portriga-Rapid paper

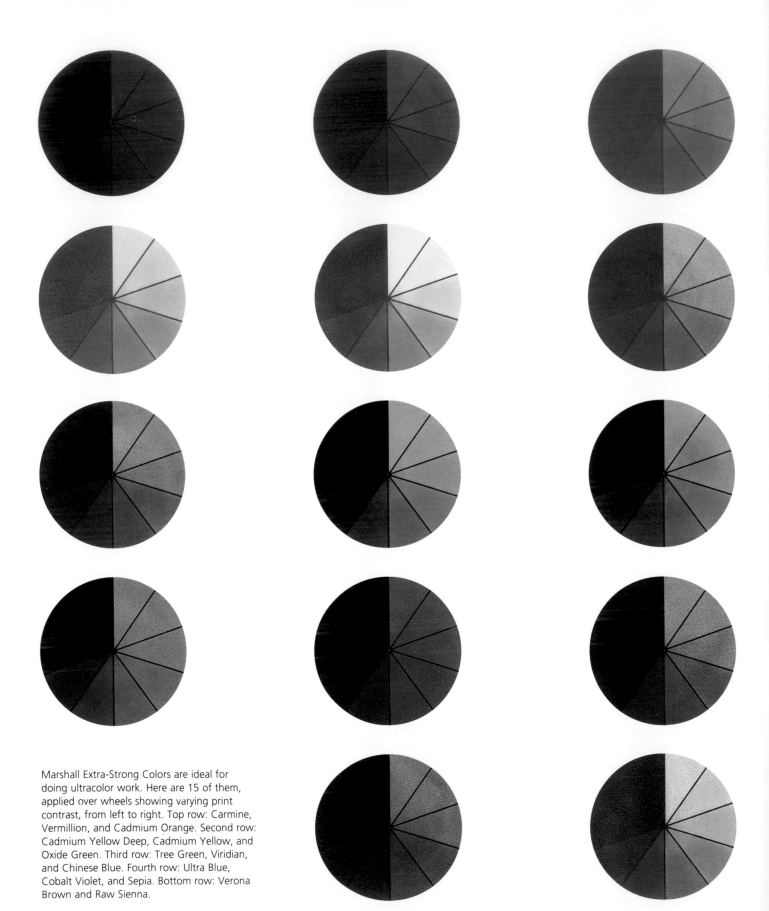

Marshall Extra-Strong Colors are ideal for doing ultracolor work. Here are 15 of them, applied over wheels showing varying print contrast, from left to right. Top row: Carmine, Vermillion, and Cadmium Orange. Second row: Cadmium Yellow Deep, Cadmium Yellow, and Oxide Green. Third row: Tree Green, Viridian, and Chinese Blue. Fourth row: Ultra Blue, Cobalt Violet, and Sepia. Bottom row: Verona Brown and Raw Sienna.

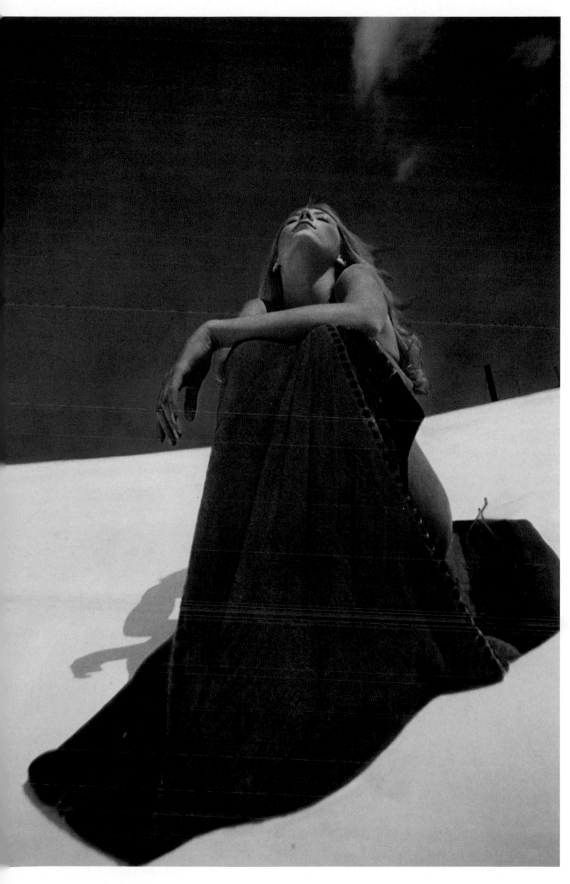

Purple Noon, handcolored on Agfa Portriga-Rapid paper.

A black-and-white print of this image lay around for seven years before I tried ultracolor on it; then an interesting image emerged. The sky contained quite a bit of photographic contrast, so the Cobalt Violet I applied to it isn't a pure color, yet its strong purple intensity was built up with successive applications of color. The Cadmium Yellow Deep that I used to color the sand beach was applied over very little photographic tone, so the final yellow is far more intense than the purple.

When you've completed the wash correctly, move on to the detailing stage. This is where the ultracolor effect becomes obvious. First, clean up the borders of the print, then add shadows with Neutral Tint, just as in the basic method. Now look at your picture carefully. The ultracolor effect is going to be most apparent in areas of the photograph that accept maximum color effect; usually that means the highlights because they are almost pure white and lack detail. Light-toned areas of the subject will show the same effect.

Proceed carefully using either a cotton swab or cotton ball that already has the desired color "crushed" into it. Using the ball that was used to rub down color during the wash is, if uncontaminated, ideal because it will yield color gradually. This is what you want, a gradual intensification of color that you can shape into areas of maximum intensity. Regardless of how intense you want the color to be, remember that it should remain translucent; that is, photographic detail should show through the ultracolor.

By the time you get to fine-tuning the image, you should have obtained most of the ultracolor effect by having selected Extra-Strong colors and then having reapplied the color in the detailing stage as instructed. However, in some cases, you might have to "tweak" the color a bit more during fine-tuning when you are finessing the final touches. You may want to add a bit more color

to various small details to make them really pop out at the viewer. I use a cotton swab, a sable brush, or a cotton-wrapped toothpick with color crushed into the tip to do this, as this gives me maximum control of the application, certainly more control than with a cotton ball. The brush, when used with a small amount of oil, lets me apply color very precisely, but I find using it is a slow process. Generally, I use brushes only to augment my work with cotton balls and swabs, not to replace either.

So that is how you create ultracolored photographs. You probably see scenes every day that lend themselves to this more intense color effect: for example, cars and diners from the 'fifties, and art-deco architecture. Certain fashion situations, such as swim suits and beach scenes, seem ideal for ultracolor, as do carousels. Still, I would never have guessed when I photographed "Girl on Couch" that this image would wind up being ultracolored. "Manhattan Rainbow," the picture on the title page, is another example of an unusual ultracolor treatment.

Again, the purpose of this book is to offer you a really contemporary look at handcoloring. Personally, I like to think that the more you know about techniques and materials, what to use and what to avoid, and how to do things, the less reluctant you'll be to trying things, to experimenting and being outrageous if you feel like it. Isn't that what art is all about?

PARKING VIOLATION, ultracolored on Forte Elegance Bromofort paper.

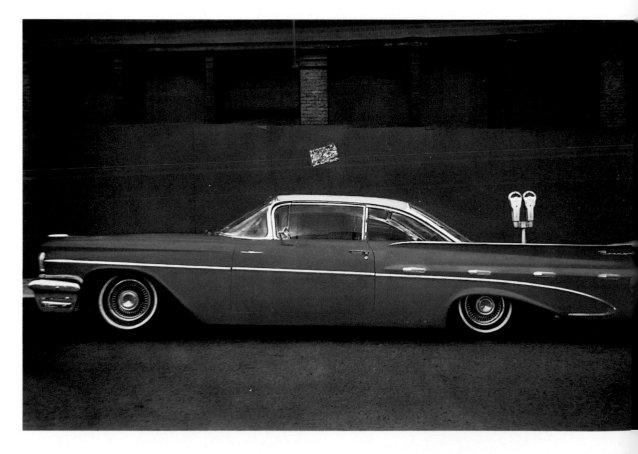

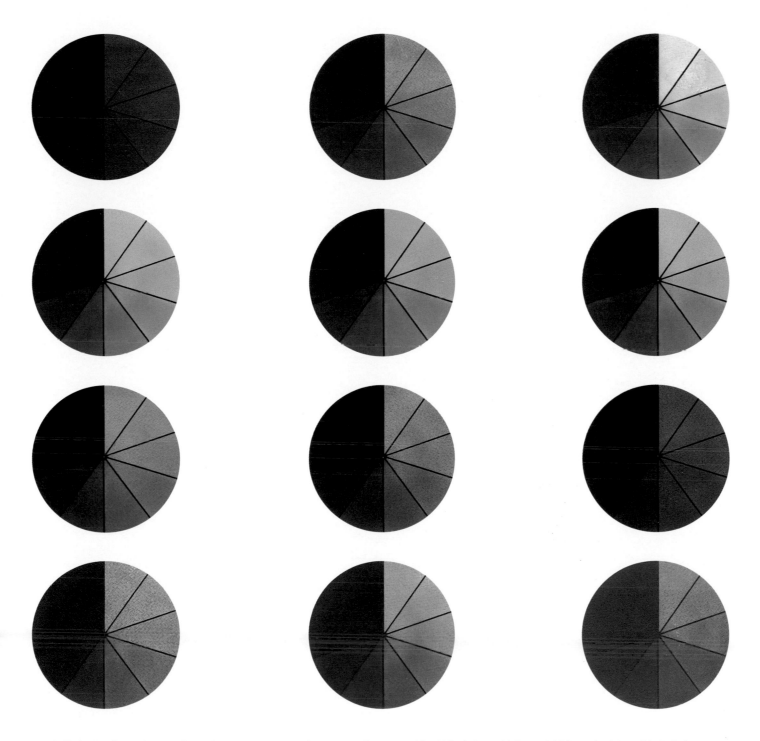

Marshall Photo-Oils can be mixed together to create new colors, many of which are good for ultracolor and some of which are slightly more opaque than normal. The three colors in the bottom row were mixed with Titanium White, which can change a color's tone. Approximate color ratios are provided for each mixed color, from left to right. Top row: Maroon (Carmine Extra Strong mixed 3:1 with Sepia); Apricot (Vermillion mixed 1:1 with Cadmium Orange); and Chartreuse (Oxide Green mixed 1:1 with Cadmium Yellow). Second row: Jade Green (Tree Green mixed 1:1 with Viridian); Emerald Green (Viridian mixed 2:1 with Cadmium Yellow); and Aquamarine (Viridian mixed 2:1 with Sky Blue). Third row: Turquoise (Chinese Blue mixed 1:1 with Viridian); Delft Blue (Ultra Blue mixed 3:1 with Neutral Tint); and Royal Purple (Cobalt Blue Extra Strong mixed 1:1 with Ultra Blue Extra Strong). Bottom row: Hot Pink (Carmine Extra Strong mixed 2:1 with Titanium White); Tropical Turquoise (1:1:1 mixture of Ultra Blue, Cobalt Blue, and Titanium White); and Violent Violet (Cobalt Violet mixed 1:1 with Titanium White).

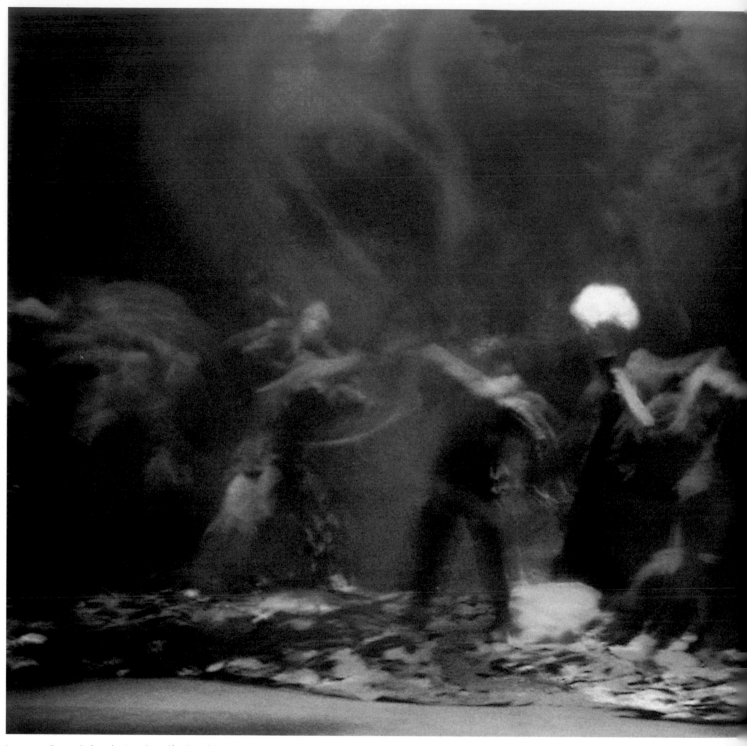

LENINGRAD BALLET 2, handpainted on Ilford Multigrade FB paper.

Photographic Handpainting

HANDPAINTING PHOTOGRAPHS differs from other handcoloring in that parts of handpainted photographs are obscured by opaque layers of paint. Whereas in other handcoloring work, even ultracolor, all photographic details remain visible after being colored, image detail is to some degree altered by handpainting. When I first handpainted a photograph, I crossed a line into new possibilities. How and why to do it, what new materials to use, and how to correct mistakes are explored in this section. Handpainting is guaranteed to bring new excitement to your work, as it takes you even farther afield from traditional photography.

AN EVOLVING METHOD

As it is presented here, handpainting doesn't venture into areas in which the painted image becomes a separate piece of art apart from the photograph. In other words, in the procedure outlined here, the photograph remains the basis for the work's content. Other artists whose work I've seen have imposed new visual images on their photographs, in some cases creating a unity between the two images, in others leaving their relationship for the viewer to guess. For example, I recently saw a handpainted image based on a photograph of a torso upon which were superimposed paintings of religious tattoos. The tattoos were painted skillfully by the artist from her own imagination. In this case, there was a logical association between the underlying photograph and the content she added to it.

However, I've also seen work in which the superimposed painting covered virtually the entire photographic surface. What remained of the photographic image was difficult to decipher, and the painting offered no clue. In this case, the photograph was essentially used as a canvas and contributed nothing to the final image. Because I harbor no illusions about being able to draw or paint, in my method of handpainting, the photograph provides the content for the painted application. You may be far more skilled at drawing and painting than I am, so you might want to expand my technique beyond these limits. However, for purposes of definition, the method I'm presenting is best described as *photographic* handpainting.

My method evolved quite by chance. The Dallas Cowboys commissioned me to do an image of their cheerleaders in ultracolor for a poster. Two photographs I took around that time led me in a new direction because neither image worked with my then-current techniques, including ultracolor. One of the cheerleader pictures taken at Texas Stadium showed empty stands in the background; otherwise, it would have been great material for the poster. Handcoloring the image would still reveal the empty stands in the photograph. I wondered whether I could fill the stands somehow and then filed the image away.

The following month, I photographed the Nissan Alamo City Grand Prix. I especially liked one shot of Geoff Brabham's #83 Nissan racing car that I had shot in black and white, but handcoloring it was frustrating. The Nissan's racing colors were a vivid red, white, and blue. Yet the side of the car to the camera was shaded, so it printed as a dark gray. With such a dark base for handcoloring, there was no way to make the car look a vivid blue. I had again bumped up against the limits of handcoloring—the intensity of the color effect is always partly determined by the underlying photograph, or more precisely, its shades of gray.

Then, by accident, I broke through the barrier. What led me to try mixing Titanium White with the Ultra Blue is unclear. Perhaps I had read in an old book that doing so would produce an opaque photo oil, but I don't know for sure. I think it was probably curiosity to see whether I could in fact come close to duplicating the shade of blue I saw in my mind's eye. Blending white with the blue produced great results: a blue that looked like the Nissan

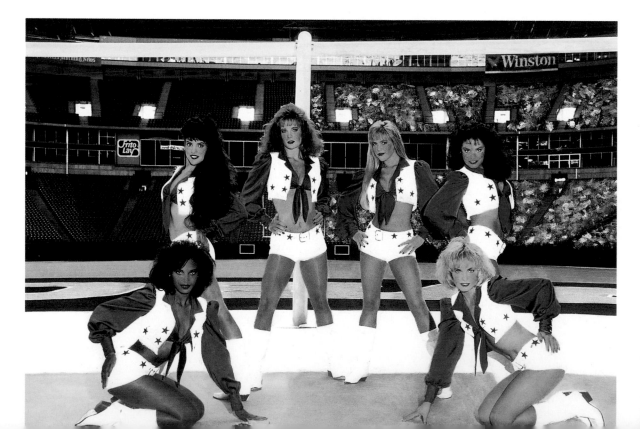

DALLAS COWBOYS CHEERLEADERS, handpainted on Agfa Portriga-Rapid paper.

Blue I remembered. Still, I had a major problem. I couldn't use it for coloring according to my established process. When I tried rubbing the color down, a mess resulted and the blue effect was lost. This was because the color was affected by the gray shadow in the photograph. When rubbed down, the white in the blend looked cloudy over the gray shadow, resulting in a muddy blue that was unacceptable. At this point I must have decided to see how leaving the blend opaque would work.

Applying the photo oil directly without rubbing it, I realized right away that I was in a totally new ball game. The photograph was still giving me visual clues for shading and details, yet, as soon as I applied color, the photograph was lost, covered up by the paint. Nonetheless, I proceeded and eventually had what I wanted, a car that was true blue! I liked the results so much that I began experimenting with other photographs and deducing some general guidelines for handpainting. Sometime during this period of experimentation, I pulled out the cheerleader picture with the empty stands (opposite page) and tried filling them with abstract color patterns like those I'd seen in an advertisement. The handpainting process worked beautifully for adding color interest away from the main subject.

I discovered, however, that not every image benefited from this technique, and that for me, sports and action images worked best. Although I've always loved sports, I hadn't photographed any prior to the Grand Prix. As a result of my success in handpainting the Nissan, I've branched into sports with gusto. Try handpainting, and see how well it works for you and the kinds of images you like to make. You'll probably find lots of ways to use it to broaden your repertoire of handcolored work.

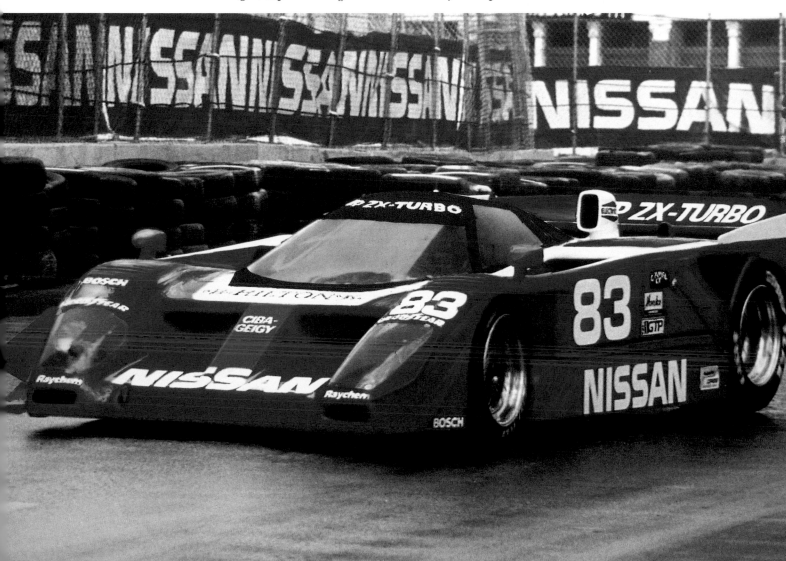

NISSAN #83, handpainted on Forte Elegance Bromofort paper.

HANDPAINTING MATERIALS

There are so many differences between handpainting and the other handcoloring techniques that it is almost a completely new field. While handpainting is best done on the photographic papers already described, depending on how much coloring and how much painting is done to the photograph, you might be able to use other papers as well. Absorbancy is not a characteristic required for handpainting because the photo oil applied remains on the surface. However, I suggest you begin your handpainting efforts using the previously recommended papers until you become familiar with the new handpainting effects.

Handpainting often involves a considerable amount of handcoloring first, so it is critical to the overall success of the image that you don't take any new shortcuts in the basic handcoloring procedure. For example, in the cheerleader picture mentioned above, its handcolored subjects were really the focus and hence how they looked was very important. The only part of the image that was handpainted were the abstract "fans" that I added to the empty stands. On the other hand, if an image requires radically less tinting because the handcolored elements are not the central focus of the work, you can be less concerned with handcoloring details and focus more on the handpainting. In the picture of the blue Nissan, there was almost no area that required elaborate handcoloring, so the absorbancy of the paper I used was less of an issue, as was the fine-tuning of the handcolored parts.

I recommend using Marshall Photo-Oils as your primary medium for handpainting; however, you might wish to experiment with other colors by trying regular artist oils, too. This doesn't mean that I recommend artist oils for handcoloring; I don't at all. However, handpainting is different. Rather than blending Marshall's colors to get the shade you want, you could try buying exactly the right shade in an artist oil and using it right from the tube.

COWBOYS VERSUS REDSKINS, handpainted on Forte Elegance Bromofort.

Although Marshall offers an extensive palette, certain colors, such as Viridian and Cobalt Violet, are too dark to use directly from the tube. They must be mixed with Titanium White *prior to application and away from the print on a palette or dish.* I suggest leaving a pure, unblended dab of both colors on the palette, so you can selectively lighten or darken the color application as you shape and shade the subject. Marshall's reds, yellows, greens, and Cadmium Orange are best used directly from the tube without adding Titanium White, as it modifies these hues

somewhat. Experiment with them and see what you prefer.

Sable brushes are best for handpainting. I suggest you acquire a good selection of the pointed-tip variety because "staying in the lines" is important and the pointed-tip brushes are easier to control, particularly the smaller ones. Because most handpainted images require a combination of coloring and painting, you'll still need a supply of cotton swabs and balls on hand, too. And as I've indicated, you'll want a palette or plate for mixing colors away from the print.

Nolan Ryan, handpainted on Luminos RCR paper.

BASIC HANDPAINTING TECHNIQUE

The primary rule for all handpainting is to do the handcoloring first. Each image differs as to how much coloring, or tinting, precedes the painting, but whatever the case, do the tinting first. Follow the basic handcoloring procedure outlined earlier, with no shortcuts. For example, I handcolor most skin tones in handpainted pictures. If I'm working on a sports photograph and the player is wearing a uniform, I tint the player's face, arms, and legs prior to beginning the rest of the work.

The reason for this rather dogmatic approach is that handpainting is much less forgiving than handcoloring. Handpainting involves a far greater application of photo oil than handcoloring. Handpainted pictures are very messy when mishandled. You're likely to get photo oil on your hands and, if you don't notice it, you'll transfer it to your clothing, your work surface, your face, and other body parts. Photo oil may not kill you, but it is really annoying. In addition to being messy, handpainted photo oils also mix together if mishandled. You don't apply one color over a former and "lift" it, as you do when you're handcoloring. Instead, if you mix colors, you create a big mess. So, since the medium is not forgiving, the best advice is to "stay within the lines."

After you've finished handcoloring an image and you're ready to begin applying "paint" to the photograph, prepare your palette. If you intend to mix photo oils with Titanium White, do so now. If your mixed colors are for shaping or shading, in addition to the mixed oils on the palette, dab a small portion of the pure colors on one side and put another dab of Titanium White opposite them. These unmixed colors are for reintroducing highlights and shadows to areas of the photographic image that have been obscured by the paint; they are also for shaping forms. Using a paint brush, blend the color into the image so that the shading effect is gradual and looks as natural as possible, working in a dab of pure color for deep shadows and a dab of Titanium White for the highlights.

When working with some paints, particularly Titanium White and reds, yellows, and oranges, I always do a really rough handcoloring over the area to be painted. For example, even if an area is very light and the intended color is white, I will swab the whole area first with a base white, then paint in the highlights with a heavier application of the same white. The underlying photograph can still be seen through the handcoloring, revealing shadows and highlights. When you then apply pure colors into the highlights, drenching the whole image in color makes it look very saturated.

In the basic handcoloring method, I save final details for the fine-tuning stage. However, in handpainting, the process is almost reversed because painting the image immediately obscures its details. For example, imagine handpainting a photograph of a brick wall covered by small signs and grafitti. If you painted the wall first, all of the details on it would disappear and it would be blank. So you start with the details and then carefully work into the larger areas.

Handpainting is not rocket science. It is, however, demanding and requires patience and care, as mistakes with this method are messier and harder to correct than with handcoloring. The key difference is that handpainting requires you to recreate highlights and shadows as well as any photographic details that disappear under the paint. This means more attention to detail *at the beginning* of your work; otherwise, your photographic references will be covered by an opaque layer of fresh paint.

To review the rules of handpainting up to this point:

1. Complete your handcoloring before you begin handpainting.

2. Use a palette to mix colors.

3. As much as possible, paint in small details first.

4. Stay within the lines.

5. Remember that the medium—pure photo and artists' oils—is not forgiving and is extremely messy.

Because handpainting mistakes can be difficult to correct, avoid contact with areas already painted. Working from the top of the print down helps, as well as working from the center to the edges. If you are painting two distinct, adjacent areas and have completed one, create a border for the second color with a small brush, running it along the border of the first color. Using that second-color border application as a "buffer," you can now apply the second color by placing your brush in the buffer zone and stroking away from the border toward the central area of your second color.

Handpainting differs in several ways from other handcoloring. For one thing, you are under less pressure to complete the work in one sitting because the thicker paint doesn't dry as quickly. You can rework the paint before it dries, and depending on the color and the thickness of the application, drying may take overnight to several days. Also, painting the details perfectly in a handpainted photograph is not as critical as in a handcolored one. Depending on your attitude toward the image, you might be more "impressionistic" when you handpaint and rely more on the impact of pure color. The painterly feel of the work makes it hybrid, a painted image more than a photographic record.

Here the handcoloring of flesh tones and certain highlights has been completed.

Using a cotton swab, I laid colors on thickly in the background.

Although the player's uniform was already white, I carefully added white paint with a small brush to improve the impact of the color.

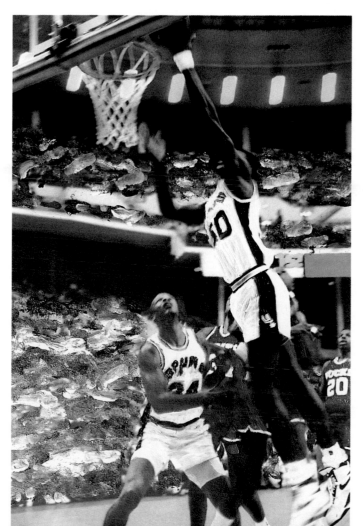

I think you'll agree that the handpainted version of this image is much more exciting than the realistic black-and-white photograph (below).

BUICK #45, handpainted on Forte Elegance Bromofort paper.

MOMO PORSCHE, handpainted on Forte Elegance Fortezo paper.

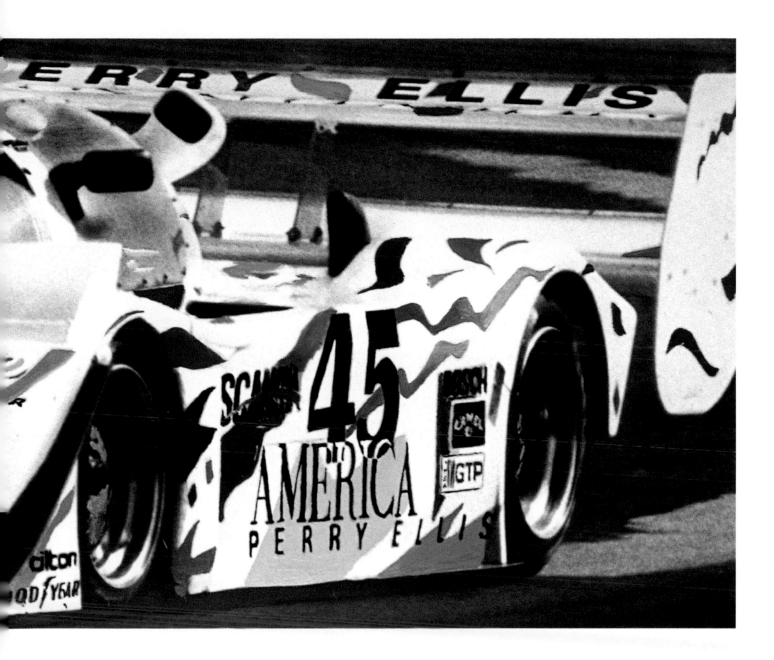

Depending on its drying time, a handpainted image is quite vulnerable to mishandling, as well as to dust and insects. More than once, insects have met their Maker after being trapped in photo oils; therefore, be careful where you keep your work while it slowly dries. One suggestion is to frame it behind glass if you can create a temporary mat thick enough to prevent the glass and painted area from touching. Otherwise, an open-air, still environment where dust is not a problem is your best solution, particularly if the print is kept vertical—for example, attached to a wall—rather than horizontal. Lying flat, it is more likely to attract dust particles settling out of the air.

The drying time for some handpainted colors can be as long as several weeks, which can tax my patience. Nonetheless, handpainting is one of my favorite activities. As you can see, I especially like to handpaint racing cars. I hope you'll try handpainting, too, and enjoy the freedom of imagination it offers.

Part Two

A GALLERY OF TWENTY HANDCOLORISTS' WORK

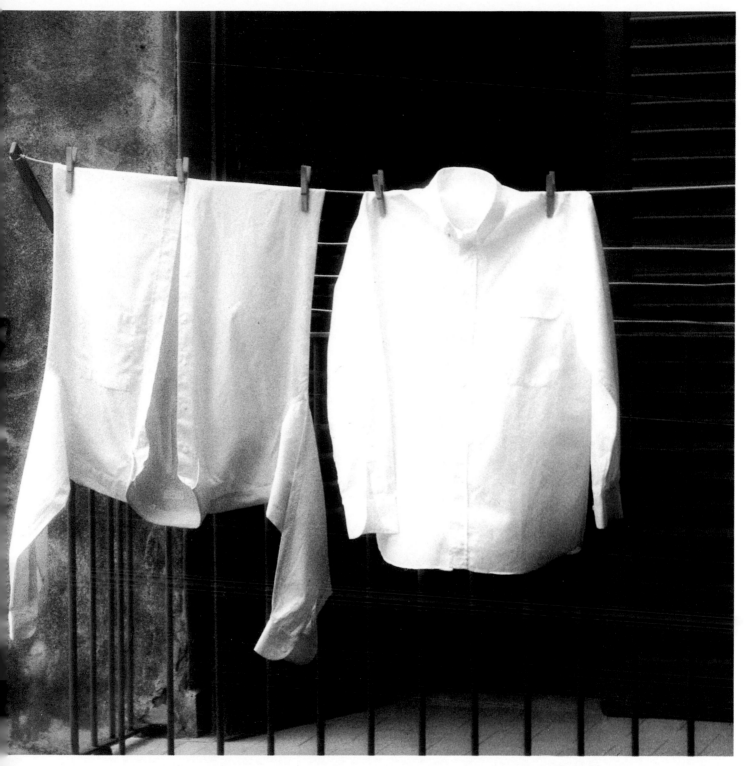

Handcolored photograph by Jill Enfield.

George Berticevich

Few people have combined philosophy with photography as uniquely as has George Berticevich, a California photographer. His subject is the Orient, geographically and spiritually. For more than two decades, Berticevich has devoted himself to understanding and revealing the way of the East from a Western perspective. His art is intended to illustrate how apparent opposites really are united if we allow ourselves to see and understand life in a more holistic manner.

In his philosophy, the circle is fundamental, as it encompasses the whole and makes the center point the only point of view. To express this in his images, Berticevich uses a Globuscope panoramic camera that rotates 360 degrees while exposing the film. This spring-wound camera is a simple mechanism to maintain, wherever he travels. He and his father also built a special camera that yields a circular image, an example of which is shown on the right.

Berticevich further personalizes his images by handcoloring them to suit his feelings about his subjects. Again, he enjoys the duality: the objectivity of the photographic image, the subjectivity of the added color. He uses water-soluble Marshall's Photo Retouch-Colors because he likes their transparency and brilliance.

Berticevich meticulously prepares his prints for the handcoloring process. He tapes a perfectly flattened print to a drawing board, and over this he lays a flexible sheet of plastic with an opening slightly smaller than the size of the print. (He prints his images with a white border around the edges and wants no color to stain the border.) Some of the other items he uses include Kodak Photo Flo solution, toothpicks, a variety of sable brushes (including some with extremely fine points for coloring small details), cotton swabs, cotton balls, a palette indented with small bowls for holding the color dye solutions, and a hair drier.

He prewets the print and keeps it wet by moistening it with cotton swabs to ensure even saturation. He applies diluted color (one drop of dye mixed into the water contained in a palette bowl) to the print with a brush, working from larger to smaller areas, being careful to apply the color very lightly because it is extremely difficult to remove. In areas filled with great detail, he recommends working with a drier print and saving the smallest details for last. He also suggests going over the colored areas with more color to create subtle nuances and to balance colors. The panoramics shown here were chosen to reveal the relationship of Heaven, Man, and Earth.

THE WAY AND THE MOUNTAIN (VIEW FROM THE TOP OF MOON HILL), March 1985.

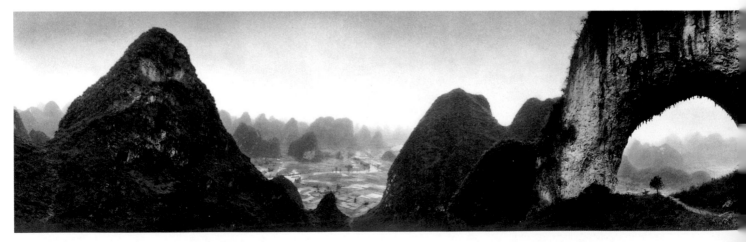

VIEW OF MOON HILL, Guangxi Province, China, March 1985.

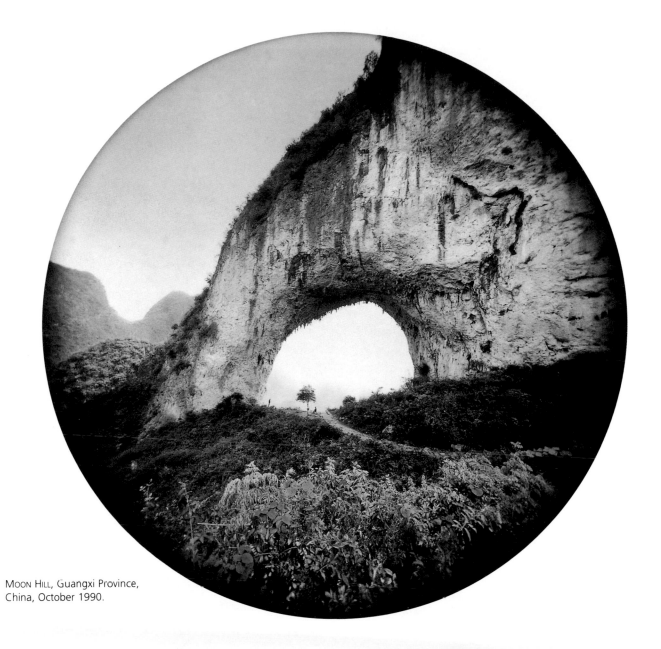

MOON HILL, Guangxi Province,
China, October 1990.

VIEW OF THE POTALA PALACE,
Lhasa, Tibet, April 1985.

LAMAS OF THE SERA MONASTERY
DEBATING TEAM,
Sera Monastery,
Northwest of Lhasa,
Tibet, 1985.

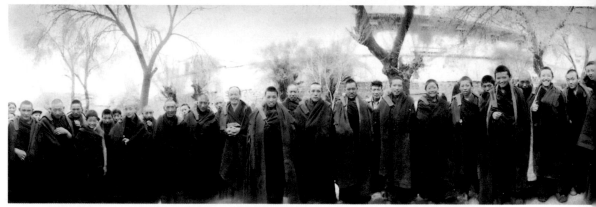

BACK ALLEYS IN THE
OLD TIBETAN QUARTER,
Lhasa, Tibet, April 1985.

RUINS OF GANDEN MONASTERY,
Southeast of Lhasa, Tibet,
April 1985.

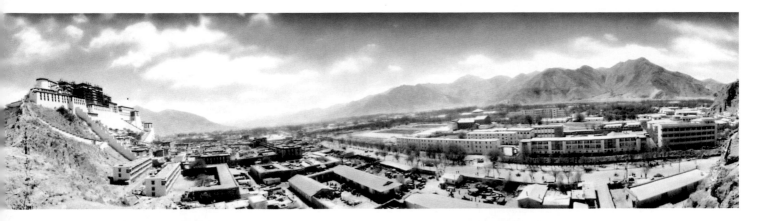

Kate Breakey

Kate Breakey is an artist from Australia who now lives in Austin, Texas. Her work was brought to my attention by Ric Collier, the director of the Southwest Craft Center in San Antonio, who described her handcoloring in superlative terms. (It appears here by courtesy of the Martin Rathburn Gallery in San Antonio, Texas, where I first had the pleasure of seeing it.)

Breakey calls the artistic process "an act of investigation —an attempt to establish a private version of an understanding of the world." Of her own work, she says, "I begin with a photograph . . . [and] smear and coat it with oil paint in many transparent layers, like layers of emotional subjectivity . . . My work is not an intellectual double-think . . . it is for the purpose of gaining access to and speaking from my soul."

In these images from her "Vital Organs" and "Remains" series, Breakey has made objects that we commonly take for granted, such as the eye and heart, appear jewel-like; and the remains of a bluebird are given honor. Who would deny that our eyes, for example, are more precious than the most polished gem? Breakey makes us look at what we treasure most yet rarely consider.

She developed her handcoloring process through trial and error, after discovering that using oil paint on black-and-white photographs was ineffective, due to its lack of transluscence and inability to bond with the paper surface. She experimented with different materials and techniques until she was satisfied with the effects she was achieving.

Breakey begins by taking a medium-format black-and-white photograph and printing it on Ilford Multigrade matte paper, usually cut from a roll, as her completed work is often 30 inches square or larger. She uses a variety of media: photo and artist's oils, pencils, crayons, marker pens, ink, and "anything else available that I find adheres to the surface of the paper," even color pigments "obtained from mineral, plant, or animal extracts . . . [that are] intrinsically related to their source." As you might guess, Breakey makes a direct connection between a subject and the materials she uses to image it.

She applies color in layers, building up colors, as well as other materials, in successive "coats." To do this, each preceding layer must be completely dry; thus, it sometimes takes weeks for her to finish a handcolored photograph, but this is what helps her create such subtle blendings of color.

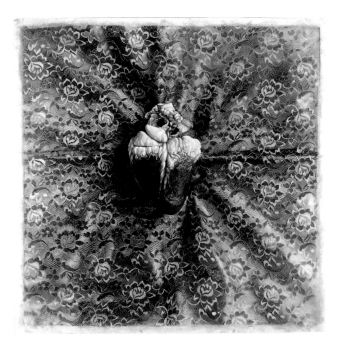

Sandra Russell Clark

Sandra Russell Clark, a photographer who lives in New Orleans, is best known for her images of gardens, ethereal landscapes, and the human form. Her art has been collected, published, and exhibited throughout the world. Her use of infrared film brings a surrealistic quality to her prints, a dreamy counterpoint to the way she precisely composes her images.

Clark's handcoloring is best described as subtle, almost imperceptible but producing a profoundly moving overall effect. For her basic print, she uses Agfa Portriga-Rapid fiber-based glossy paper and tones it brown. This creates the warm earth or skin tones she desires. She then applies Marshall Photo-Oils with swabs handmade from cotton and toothpicks.

She likes to work with colors that come from the same chromatic families but that aren't necessarily found together in nature. Some critics have said that the contradiction between the colors Clark chooses for her subjects and those we would expect to see is what creates such satisfying ambiguities in her work. Restraining the colors, she also limits the areas of the image where she applies them, sometimes leaving large areas uncolored; yet her images always convey a unique sense of completeness when she is finished.

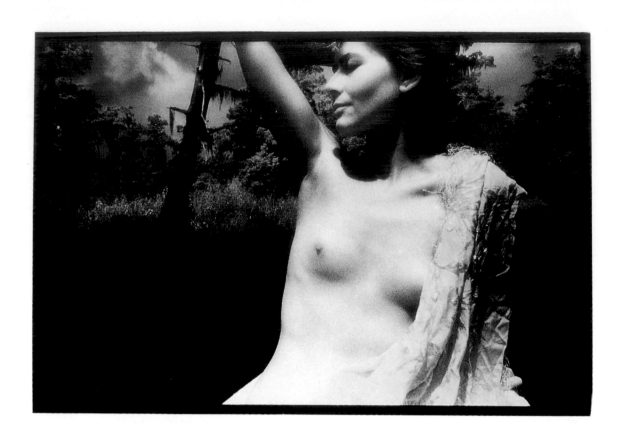

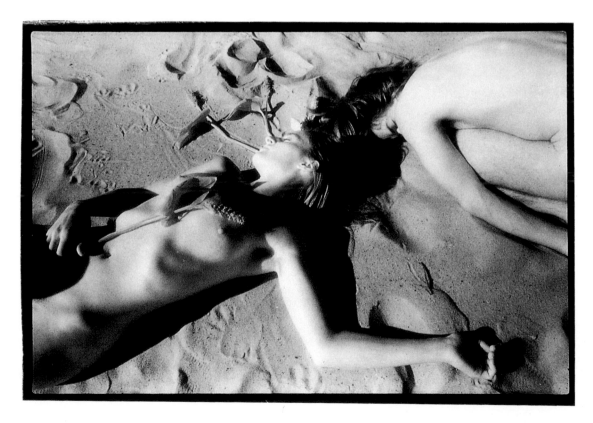

Marilyn Conway

Marilyn Conway resides in New Mexico and brings her background as a painter to her handcolored photography. She uses infrared film to enhance the dreamlike, painterly quality she wants in her images. Infrared film produces distinct visual differences from conventional black-and-white film. Among these—and especially important in Conway's art—are a clear delineation between the sky (which infrared film makes dark) and clouds and vegetation (which appear much lighter than normal). Infrared film also produces a grainy image that adds to the dreaminess of Conway's vision.

These images reveal a connection between the artist and a place, showcasing the beauty of the Southwest, the juxtaposition between the traditional and the modern, and the multicultured aspect of the area. Conway photographs in small towns and villages, searching for "uncommon signatures left on the land" and presenting them "with a hint of surrealism."

She prints her photographs exclusively on Agfa Portriga-Rapid matte paper. In come cases, first she spot-bleaches a print to highlight certain areas, then bleaches and sepia-tones the entire print. She uses Marshall's pencils and oils, reduced with Marshall's Extender and applied with cotton swabs and balls, and she works colors into colors on the print to give her work a more painterly effect.

Conway says, "I approach work on a handcolored photograph the same way I do a painting, putting large areas of color down, constantly changing color until I feel it works, and then tightening the image up. I rarely paint one photograph at a time but usually work on three to five during one session."

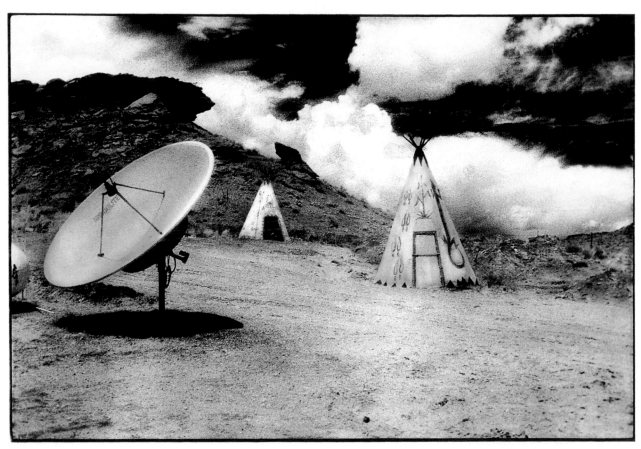

TRADING POST, Arizona.

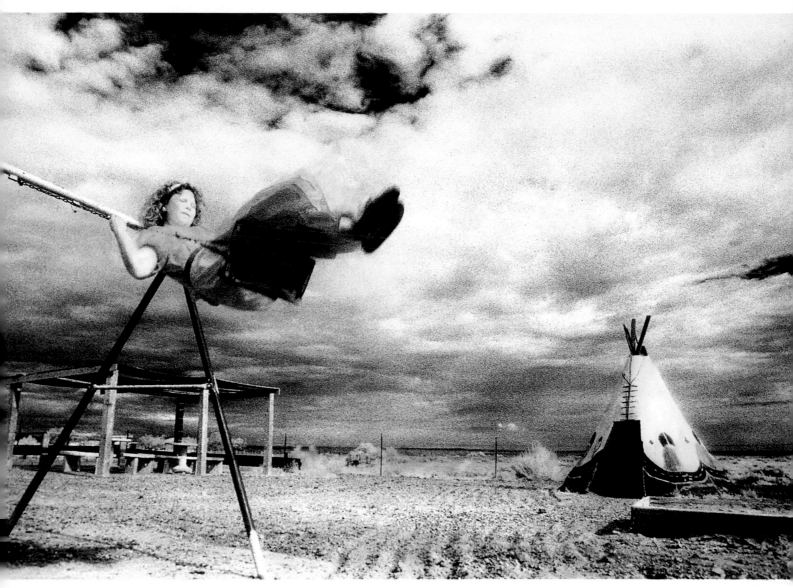

Swinging High on Route 66, New Mexico.

Rita Dibert

Rita Dibert, a resident of Rochester, New York, has been handcoloring photographs since 1974, when she first saw a demonstration of handcoloring techniques. She was taken with the medium immediately and says, "I've since realized that handtinting represents the perfect blend of detailed photographic imagery and hand manipulating with paint, a medium I've been at home with since childhood."

A painter before becoming a photographic artist, Dibert was experienced with artists' oils but found that none could provide the transluscent effect on a photograph that Marshall Photo-Oils could; hence, she uses them exclusively. She mixes her colors on a separate palette, a piece of mat board covered with wax paper, and uses hand-rolled cotton swabs made with long-fiber cotton and Japanese toothpicks. Dibert buffs down areas with lots of details in her images so that the details will show through the color; while in areas that she really wishes to add lots of color, she applies it with heavier, painterly strokes, again using the hand-rolled toothpick swabs.

A bold use of handpainted color characterizes Dibert's work on these two pages. Dibert printed the underlying photographs on Agfa Portriga-Rapid paper and toned the prints with selenium. She works in a rather large scale— 16 x 20 inches in all cases—and often uses infrared film and a red filter for her photographs. Although she works with a very precise Leica camera, her final images are loose and impressionistic, as she likes to reveal the strokes of her heavy application of paint.

Jill Enfield

Jill Enfield is a photographer who lives in New York City. Her handcolored images have appeared in many magazines and advertisements, as well as in numerous art exhibits. For the last ten years, she has taught at various photographic institutions, and many of her images have been published as art cards. The haunted, nostalgic quality of her work results in part from her exposing the images on infrared film.

Enfield prints her images on Kodak Ektalure G-surface (fine-grained luster) paper. She likes its "tooth," or absorbancy, as well as its tonal range. To handcolor a print, Enfield first attaches it to a mat-board easel that she also uses as a blotter. Then she applies various media—including Marshall Photo-Oils and pencils, and artists' oils and pencils, too—as delicate washes of color. To remove unwanted color, she uses distilled turpentine very carefully, as repeated use of it on the same area can damage the print's emulsion. She sometimes also uses turpentine sparingly to thin a color's effect.

As these images show, the delicate hues that Enfield uses create an ethereal effect. Enfield mixes her colors on a palette and applies them with wrapped toothpicks, rubbing the color down with cotton balls. Working precisely in small areas, she employs two wrapped toothpicks: one to apply color and the second to smooth it out. If she is using pencils, first she "draws" with a light touch, then uses turpentine applied with a cotton-wrapped toothpick to smooth out the pencil marks. Enfield's meticulous work habits have their reward in her beautifully balanced final artworks.

Michael Gesinger

Michael Gesinger lives near Seattle, Washington. His handcolored work has been exhibited internationally and featured in many publications. He styles his figurative work as fantasy, not surrealistic, but gentle and warm. He works in a medium format and generally with natural light.

For his images of the female form, Gesinger tones his prints selectively with selenium—either for a deep, rust-brown tone or for lighter, more subtle brown tones—after printing the images on Agfa Portriga-Rapid or Oriental Portrait papers. The toning provides a warmer base for his nudes' skin tones, yet the whites within the silver prints remain almost pure white. He correlates his choice of paper surface with the effect he wants to achieve. For example, with Agfa Portriga-Rapid glossy paper, he produces very soft, subtle coloring effects, while with the paper's matte surface, he achieves more intense colors.

Gesinger uses Marshall Photo-Oils and pencils to color the prints, applying the colors with cotton-wrapped skewers of varying thicknesses, depending on the size of the area he is coloring. To obtain a delicate color effect, he mixes his colors with extender in a 1:1 ratio when working on a matte or semi-matte surface. No such reduction is necessary when working with glossy paper. He applies the color with a light, circular motion, then absorbs the excess with cotton attached directly to his moistened index finger.

To remove unwanted color, Gesinger employs three methods: Marshall's Marlene solution judiciously applied, a kneaded rubber eraser, or a clean cotton-wrapped skewer for working with glossy surfaces. Since his handcoloring is very light, his prints dry within a few days. He then mounts and mats them with acid-free archival museum board, and signs and numbers them for collection.

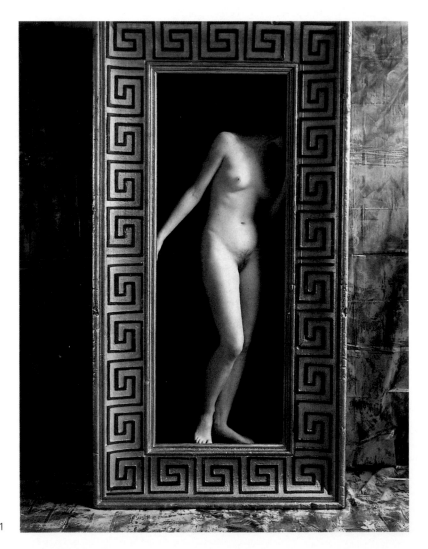

NUDE IN FRAME #1

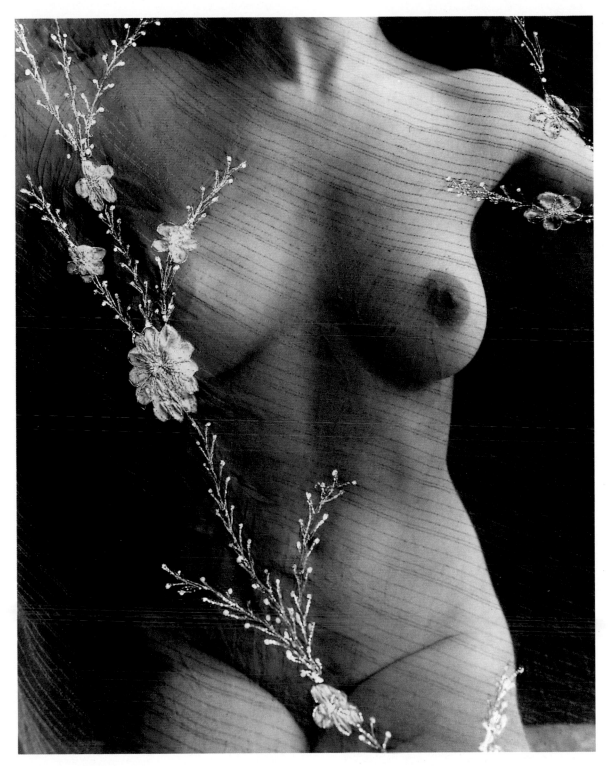

Behind the Flowered Veil #1.

Deborah Gilbert

Deborah Gilbert is a clown. Well, she used to be. She grew up wanting to be a clown and actually spent a year with the Ringling Brothers and Barnum & Bailey Circus. She also studied art for a decade, learned photography with a gusto, and became a photography editor for The Image Bank, one of the world's largest stock agencies.

Gilbert happily combines her three great loves—photography, painting, and clowns—into one through handcoloring. She is currently working on creating handcolored stock images of a variety of subjects for The Image Bank. In addition, she still clowns when asked and is working on two books. Her publishing projects deserve attention, as Gilbert has used her handcolored clown portraits to do fundraising for a very worthwhile cause, the Muscular Dystrophy Association. She has self-published three calendars of handcolored clowns and children, afflicted with muscular dystrophy, whom she made up as clowns at the muscular dystrophy summer camp where she assists annually.

Gilbert prints her images on Kodak Polyfiber F-surface (glossy) paper, giving them a slight underexposure and then sepia-toning the prints. Using Marshall Photo-Oils, she applies a lot of paint to a print with cotton swabs, then works it into the surface with wads of cotton. She prefers to mix her colors on the print directly and uses the cotton to buff the surface, leaving just the amount of color she likes. Because her paper's surface is glossy and less absorbant than other papers, she creates a more pastel effect in some areas of an image and a more textured, richer color effect where she buffs less.

ADAM, 1990.

CHRIS, 1990.

RICHARD FICK.

Sid Hoeltzell

Sid Hoeltzell is a commercial photographer, working out of Miami, who incorporates a wide range of handcolored images within his overall portfolio, including these two strikingly different pictures in which handcoloring created "the difference" needed to sell them in the marketplace.

For the Miami Opera 1993 Season Poster on the opposite page, Hoeltzell wanted to capture the nightlife Miami is famous for in "intense colors;" to do so involved combining several images. First, he photographed the couple in color in a studio with tungsten light for added warmth. Then he shot the background at dusk to bring out the city's neon colors, again on color film. Each image was enlarged to 16 x 20 inches and merged together by a professional lab into a 16 x 20-inch color print.

Using both Marshall Photo-Oils and Dr. Martin's watercolors, Hoeltzell intensified the neon color in the background and brought up the skin tones of the subjects, as well as the colors of their costumes. Matte-spraying the print to increase its "tooth," he applied grease-pencil lines to bring out edges and texture, an effect most apparent in the palm trees. This picture is a good example of the maverick directions you can take in handcoloring, such as adding color to a color print!

Hoeltzell created the picture below as a self-promotional piece, entitled "Grand Marnier." Whereas his other picture is saturated with color, the opportunities for coloring this image were far more subtle, yet rich. Photographed in black and white, the image was printed on Agfa Portriga-Rapid paper. Then Hoeltzell applied a layer of color with Peerless water-based dyes, tinting the liquor in the glass, the bottle, and the orange peel for maximum color saturation. He then treated the print with PMS solution and colored the background and table with Marshall Photo-Oils, adding some Cadmium Orange over the dyed orange peel for further color emphasis. This process is an interesting way of using two different media in sequence for color enhancement. When the oil dried, he sprayed the print with matte finish and drew on it with grease pencils to add texture for further impact.

Hoeltzell's term for this technique is "skeleton style." In his words, he approaches handcoloring "with the style or format of an old masters' painting: the basic colors of the image (or the skeleton) are created with watercolor; then the skin is finished off with oil." The skeleton should be rendered in the basic colors previsualized for the image, colors that support the rest of the work. In the case of the Grand Marnier image, the basic colors are red and orange. Hoeltzell likes to use water-based dyes beneath oil colors because the transparent oils can't render the intense colors he wants without support from the underlying dyes. His approach to handcoloring demonstrates how artists develop their own styles with this incredibly adaptable medium.

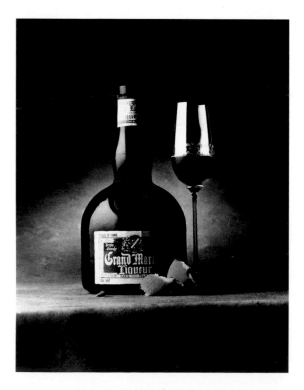

GRAND MARNIER

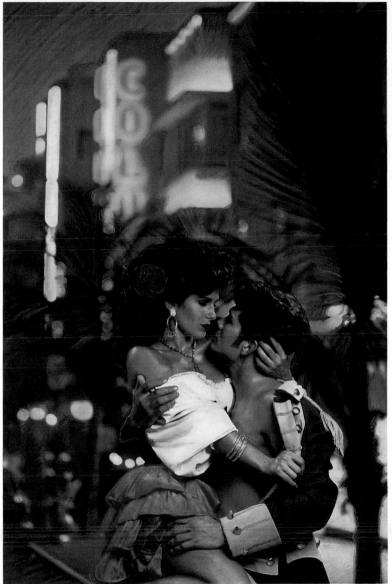

Poster for Greater Miami Opera, 1993 season.

Deborah Keller

Deborah Keller is an artist who lives in San Antonio, Texas. Her handcolored work is both delicate and sensual. She has exhibited regionally and teaches art in a public school. Keller carefully combines color and composition to create elaborate images that she sometimes further enhances through collage. She prefers printing her images on a semi-matte fiber-based paper and works with oils, dyes, pencils, pastels, and chalks. She also uses such other materials as gold leaf, ribbons, small beads, and glitter particles to work the picture farther and farther away from the original photographic image, thereby creating a new artistic image.

In the untitled image opposite, Keller combined numerous photographic images—taking the eye from one, the lips from another, a repetitive series of a woman in a hall from another—which she reconstructed against a textured background and rephotographed to produce a final print then handcolored with Marshall Photo-Oils. The image below is really a collage of many different materials colored with metallic paints as well as oil paints.

Brenda Miles

Six months ago, during my search for handcolorists to include in this book, a friend recommended Brenda Miles, another Texas-based handcolorist. While talking with her by phone, I mentioned an article on ultracolor I had written for *Darkroom Photography* magazine. Her reaction was as unexpected as it was flattering. Not only had she read it, she had put it to use. Seeing Miles' work proved my theory that someone would take my ultracolor technique in a totally new, creative direction, adding to it, modifying it, even in her case, giving it a new term—Toxic Color!

Miles' sense of humor is wonderfully illustrated in her imaginative images. "Godzilla Goes Vegetarian" provokes instant, irrepressible laughter. "Texas Stud" mixes a pinch of discomfort in with the laughter if one is a Texas male. As for "Cruel Shoes," well, has our heroine been left behind, or did she escape a crueler fate? Miles' use of color is indeed toxic, yet the delicate hues blended into the sky in "Cruel Shoes" are beautifully subtle as well as vibrant.

Miles says that after she fell in love with the darkroom, she began looking for other ways to manipulate her photographs. No longer satisfied with black-and-white images alone, handcoloring seemed a natural progression for her art. When she first began, not much information on handcoloring was available, so she began experimenting, persisting despite many futile attempts.

Miles arrives at her blend of colors in novel ways. She uses photo pencils—both Marshall's and Berol Prismacolors—more than photo oils. After applying the pencil color, she uses her own solution—a combination of linseed oil and turpentine mixed 1:1, applied with cotton balls, swabs, or wrapped toothpicks, depending on the size of the area—to smooth out the pencil marks and spread the colors.

She describes her selection of colors as intuitive, and says she holds the pencils in front of her and then "goes for it." If she doesn't like the way an image is turning out, she erases the color with a Magic Rub vinyl eraser and begins again until the feeling is "right." She prefers to begin with a base color, then layer it with more colors, either blending them or allowing them to remain separate and distinct. She calls her approach one of "wild abandon," and as these images reveal, she is a serious artist with fantastic wit.

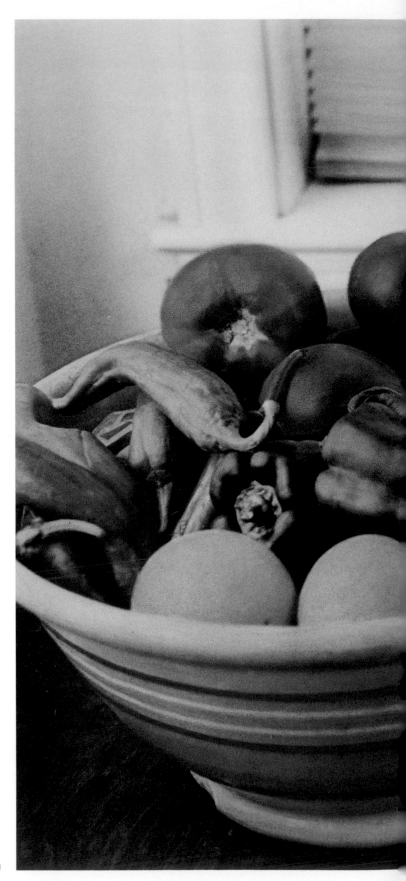

GODZILLA GOES VEGETARIAN

CRUEL SHOES

"Texas Stud" 11/75

TEXAS STUD

Geoffrey Nelson

Geoffrey Nelson, a photographer from the San Francisco area, has created a commercial niche for his unique handcoloring technique. Two of the three untitled images you see here were made using the Polaroid image-transfer process on pictures originally photographed on transparency film. Each of these transfers was made with an 8 x 10 Polaroid by separating the emulsion portion of the Polaroid film from its backing, then transferring the emulsion to paper that was then carefully handcolored. (For more detailed information on this process, see page 122.)

The image on page 102 began as a black-and-white photograph of a statue, printed in the darkroom on watercolor paper that had been coated with "Liquid Light," a photo-sensitive liquid emulsion that can be applied to a variety of materials. The print was painted with gold and copper paints, and then placed on a light table over a mask with words cut out to emit light from below. More words were projected on top of the print, and other objects were placed on top of it. Then the entire image was rephotographed as a color transparency for commercial use in a printer's brochure to illustrate the concept of the sixth sense.

The still life on page 103 began as as a 120mm color transparency, then it became an 8 x 10 Polaroid transfer, and was finally handcolored with photo oils and liquid dyes. Nelson created this image for an annual report.

This nude is from Nelson's personal collection and consists of a photographic image fused with a projected background. This picture, as well as the other two commercial pieces, is a highly manipulated image, with considerable conceptual work in the preplanning stage, and numerous steps between the concept and the final art piece. Originally shot on 4 x 5 color transparency film, Nelson handcolored the 8 x 10 Polaroid transfer with photo oils and liquid dyes.

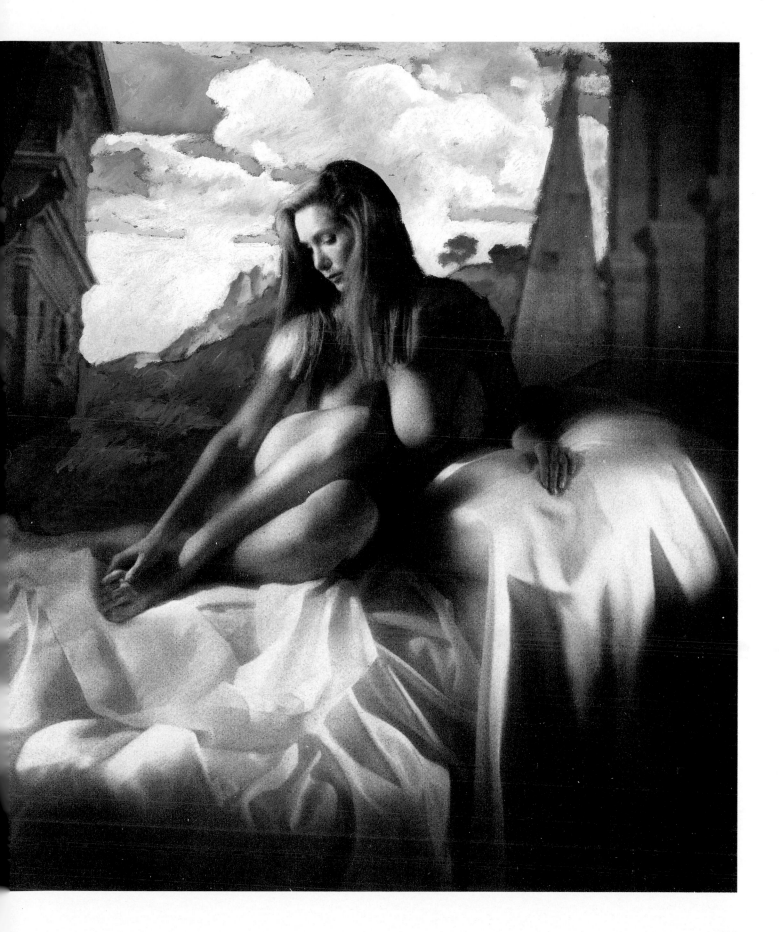

Kelly Povo

Kelly Povo is based in Minneapolis, Minnesota, and she travels quite a bit. You've probably seen her handcolored work on various cards and posters that are sold coast to coast. Although it was difficult to choose from among her many exciting images, the nighttime neon images you see here are so uniquely hers that it is a pleasure to showcase them. Here is how she describes her work:

"These pictures capture the essence of my portfolio. I've traveled across the country for the past 12 years photographing 'Roadside Americana,' with an emphasis on nighttime neon. I shoot 4 x 5 Tri-X film, exposing it from 5-20 minutes using a zone-system technique of over- and underexposure that I devised for my own camera gear. I print on a variety of papers, depending on the desired result; my favorites are Ilford Gallery and Agfa Portriga-Rapid fiber-based papers. I handcolor my images with Marshall Photo-Oils as well as other standard oil paints that I've tested for transparency and brightness.

"As you can see, I like a very bright style of coloring that really brings neon signs to life. I use colored pencils for very fine details but, generally, cotton wrapped on a toothpick or cotton swabs work just fine. Handcoloring is an excellent way for me to capture the images I'm most drawn to and really make them sing. Have fun and experiment, that is the best way to learn!"

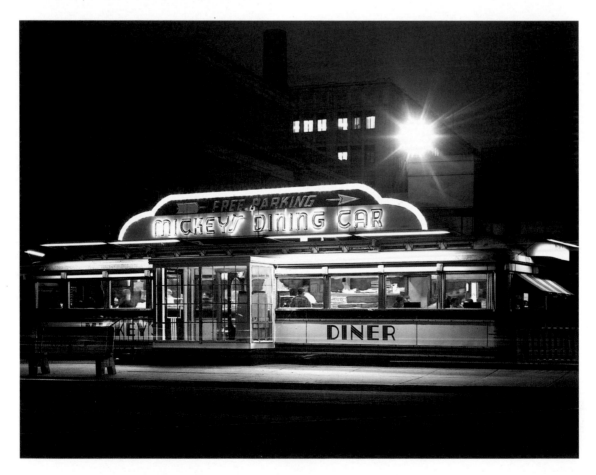

Gulnara Samoilova

Gulnara Samoilova hails from Ufa, Bashkiria, formerly an autonomous republic in the USSR. She now lives in New York City and has been involved in photography since 1980, having taught and exhibited in both Russia and in the United States. She began handcoloring her photographs after seeing a visiting exhibition of work by two English photo-conceptualists in 1989. She envisioned handcoloring as a means of doing whatever she wanted to express what was "hidden" in a photograph, an appropriate technique for commenting on what is hidden in social life as well.

She usually handcolors with photo oils, leaving parts of her black-and-white prints untouched to depict "real life" and adding color to show the imagination, the life of the mind. Her photographs are of Russia, its people, their problems, and their relationships. She often thinks her subjects are trying to say something but cannot; that is why she adds their thoughts in balloons to some of her pictures.

In Samoilova's work, you can see how her coloring and painting take on their own identity apart from the photographic image. She makes no attempt to use color for any type of photo realism but uses it in conjunction with the black-and-white image to finish the message she wishes to express. The picture on this page is meant to call attention, through her art, to Samoilova's concern about AIDS as a global plague. The rest of her images here show Russian life in transition, during an historical period when life has been difficult, pleasures simple and scarcely to be enjoyed while the grind of life is endured stoically.

Poor Boy!
Careful: AIDS!

106

LIPSTICK.

стесняется

He is shy.

THE MIRROR.

НУ ЧТО, СТАРУШКА? ПРОЖИЛИ ДЕНЬ — ПРОЖИВЕМ И ДРУГОЙ!

So Grandma? We survived one day, we'll survive another.

Wendi Schneider

Now based out of New York City, Wendi Schneider is a fine artist whose images have also found favor in the commercial arena. Not only has she been featured in galleries across the world, but her published work includes over one hundred images on book and magazine covers, and on many art cards. Here is how she describes her technique in her own words:

"My handcoloring developed from my background as an oil painter. Unlike traditional handtinting, where the paint is applied and wiped off to leave only a hint of color, I usually build up layers of colors to achieve more depth and subtlety. My photographs are printed on Agfa Portriga-Rapid paper, and some are sepia-toned. I prefer working in the 16 x 20-inch to 30 x 40-inch range.

"To do the coloring work, I use synthetic or natural brushes for oils, and I use paper towels and my fingers, too. My largest brush is three inches wide, but I mostly use brushes smaller than an inch wide, and many are very fine. I use Marshall Photo-Oils, oil sticks, and sometimes regular oil paints in tubes. My palette has replaceable waxed-paper sheets and is fitted with a plastic cover to prolong the life of the paint. Sometimes I use undiluted paint, or I add a medium, like Windsor Newton's Liquid, to thin the pigment and to add gloss.

"I frequently use gum turpentine as a thinner, although it can be sticky and attract dust. I'm afraid I'm addicted to the smell of good turpentine. My mother and grandmother were painters, and the aroma always evokes pleasure. I use Marshall's Marlene solution to remove paint from the edges of the image.

"I generally work on several images at once because I must stop often to let paint dry between layers. Even then, it is very easy to disturb the underlying paint, especially by using too wet a brush or by applying too much pressure. I also enjoy working on different-sized images and different techniques at the same time. I might be working on a piece with heavy paint or broad areas of color, using a large brush, and at the same time be working on a very delicate detail with a tiny brush on another print.

"Each image is unique. I rarely try to paint an image the same way twice. Everything I know about handcoloring photographs I've learned by trial and error, and I hope to explore and refine new techniques each time I approach the easel."

DESIRE

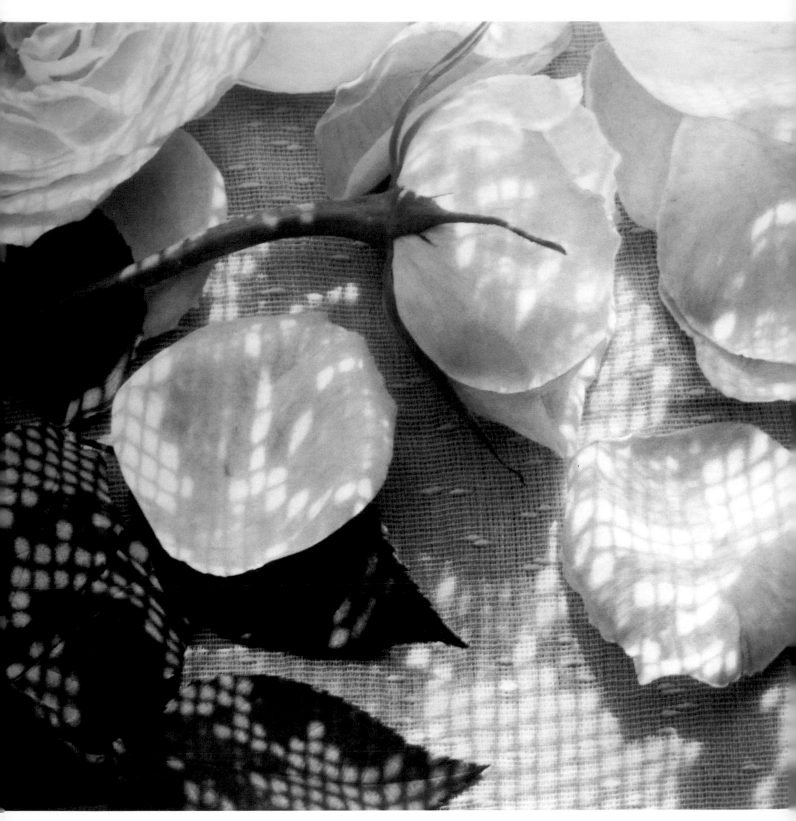

Dappled Roses II

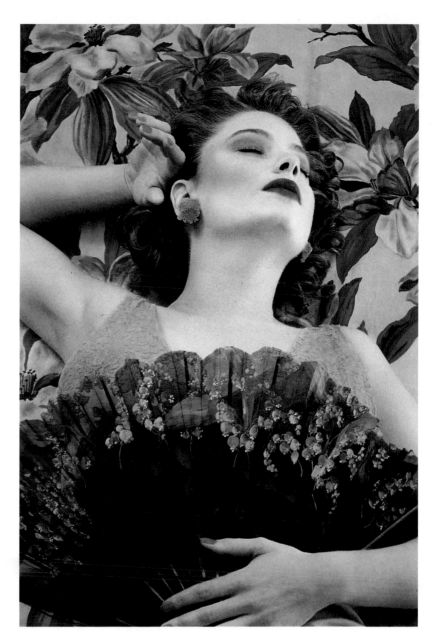

Beverly/God of Nightmares

Greg Spaulding

Greg Spaulding is a resident of Corpus Christi, Texas, whose images are heavily influenced by his travels in Mexico. Originally trained by the Navy as a photographer, he spent ten years as a commercial photographer before his hunger for aesthetics sent him back to school to study art and photography. He now pursues freelance commercial work as well as being an adjunct professor of art at Texas A&M University at Corpus Christi. In addition, he sells his personal photography as fine art, some of which is handcolored. His exploration of alternative nonsilver ways to create photographic images has contributed significantly to his growing reputation as an artist.

Spaulding's images in this book are all examples of the gum-bichromate process of printing colored photographic images. He further enhances their color through subsequent handcoloring with art pencils. The gum-bichromate process was popularized by pictorialists in the latter half of the nineteenth century and experienced a revival during the 1960's by artists seeking alternatives to the standard silver-based printing method. The process is labor intensive. First, a sheet of rag paper must be coated with a mixed emulsion of ammonium dichromate, gum arabic, and artist-quality watercolor pigment. After it has dried, the emulsion-coated paper is placed under an enlarged negative (or positive) in a contact-printing frame. The paper's position in the frame is registered for future exposures, then exposed to an ultraviolet source and developed in water.

The resulting image is faint but will be enhanced, as the process is repeated until the desired effect is achieved. An interesting option in the printing process is printing from a paper negative. You create a paper negative by making a regular paper print, then contact printing it with an unexposed piece of enlarging paper, so that the print is its reversed or negative image.

As with handcoloring, the choice of watercolor pigment is subjective; however, in the gum-bichromate process, it creates, not merely colors, the photographic image. Each pigment-emulsion exposure brings a distinct hue to the print, so you can create a variegated image according to the pigments and number of exposures employed. When the photographic image is complete, it is ready for manipulation with the handcoloring techniques already discussed. Every gum-bichromate print is unique because there are always subtle variations between prints, even when all the materials and processing are painstakingly and meticulously kept the same.

Keep in mind that every print requires numerous steps, including repetition of the emulsion-layering process, the drying, the exposure, the drying again, and the careful registration of the print and negative so that subsequent exposures register precisely with previous ones. A single gum-bichromate image might take days to print before handcoloring. Yet, as you can see in Spaulding's images, the beauty of the final gum-bichromate image motivates aspiring artists who wish to experiment with alternatives to the traditional photographic process.

SACRE UXMAL, 1990.

VENUS TRANSFIGURED, 1991.

SUENOS CARNIVALAS, 1989.

HOMBRE CON GLOBOS, 1988.

Tim Summa

Tim Summa heads the photography department at the Southwest Craft Center in San Antonio, Texas. Both a scientist and an artist, Summa was trained as a doctor before becoming a photographer. His work with the Polaroid image-transfer process is extensive, and he has encyclopedic knowledge of photography and a robust enjoyment of the printed image.

Essentially, a Polaroid image-transfer involves creating a Polaroid-produced image on a material other than the paper intended for it in the Polaroid processing pack. The first step in the transfer process is exposing the Polaroid film, either in-camera or as a form of copy art. The in-camera method is preferred by Summa because the result is a one-of-a-kind, original art piece. The latter can be accomplished by projecting an original 35mm transparency in a Polaroid Daylab unit.

The second step is selecting and preparing the alternative paper or material for receiving the image. Summa recommends using 100 percent natural fibers—paper, cloth, or silk—for best results. A fine matte art paper is a good choice, as it is receptive to handcoloring materials after the image transfer is completed. An excellent example is Crescent Vellum one-ply paper, available at most art-supply stores. It should be soaked for at least an hour in tap water before the transfer process.

The third step is processing the Polaroid film. Timing is critical in image transfer, as with all Polaroid processes. There are differences in development among the various Polaroid products, so it is best to choose one—preferably Type 669 (pack), Type 59 (4 x 5), or Type 809 (8 x 10)—and learn to work with it. According to Summa, these Polaroid products give the most predictable results. Designating the initiation of the processing as zero seconds, the film should remain together for about 20 seconds: no less than 18, no more than 23.

Summa stresses that upon separation, there be no delay in sandwiching the negative with the transfer paper. He says that he begins separating the negative from the Polaroid paper at 19 seconds and has the negative positioned on the new transfer material in 2 to 3 seconds. While the negative is still processing, ensuring proper contact with the receiving paper is necessary. A large brayer (printer's roller) with a rubber surface, or even a rolling pin, rolled over the "sandwich" two or three times creates sufficient pressure.

After about 2.5 minutes from beginning development (second zero), it is time to lift the negative from one of the four corners, keeping slight but firm pressure on the opposite corner to prevent marring the image. Then the transferred image should be set aside to dry; after that, it is ready for handcoloring. As is evident in Summa's still lifes, color can even be added around the image on the paper that "frames" it. Generally, handcoloring on Polaroid transfers is used to increase color saturation, as in the sunflower figure on the opposite page. There are so many possibilities for handcoloring with the Polaroid transfer process that Summa's images (and Geoffrey Nelson's Polaroid transfers on pages 100–103) should serve only to whet your appetite; they demonstrate the beauty of the process when artfully performed.

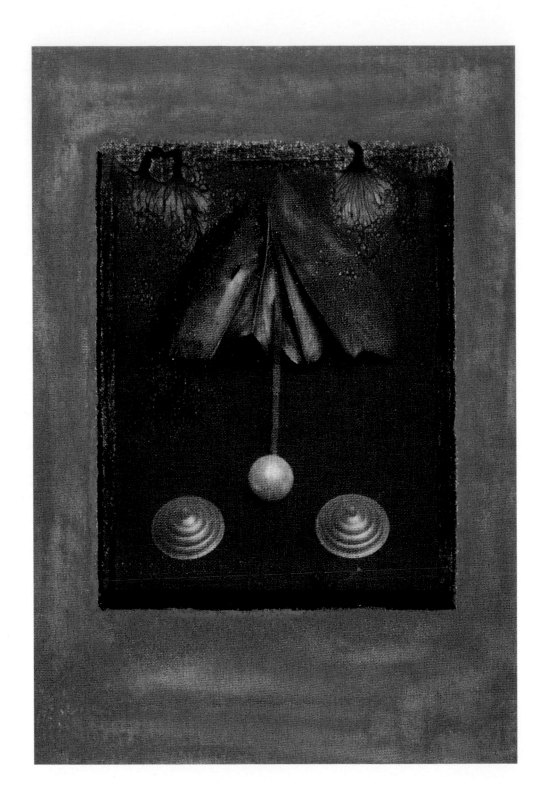

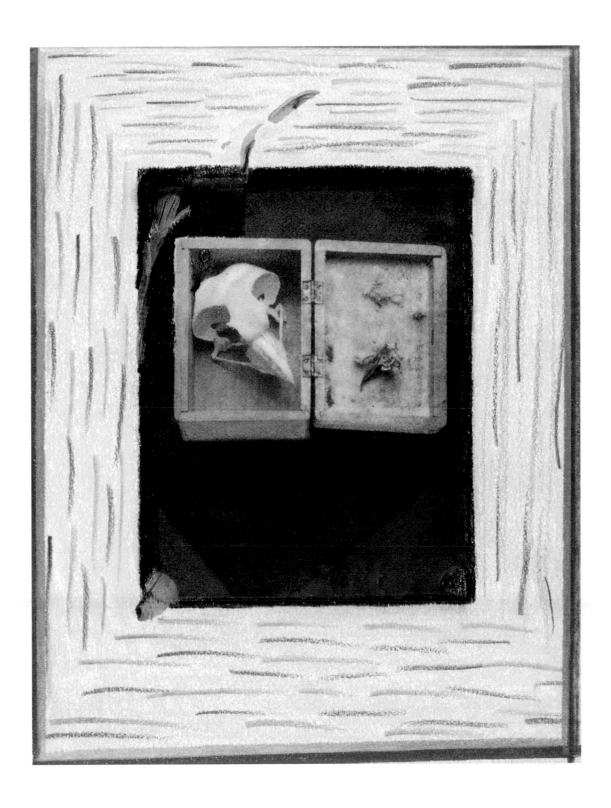

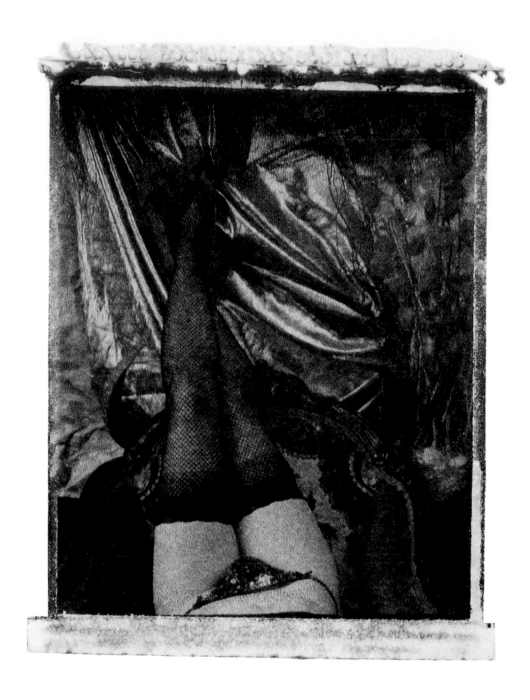

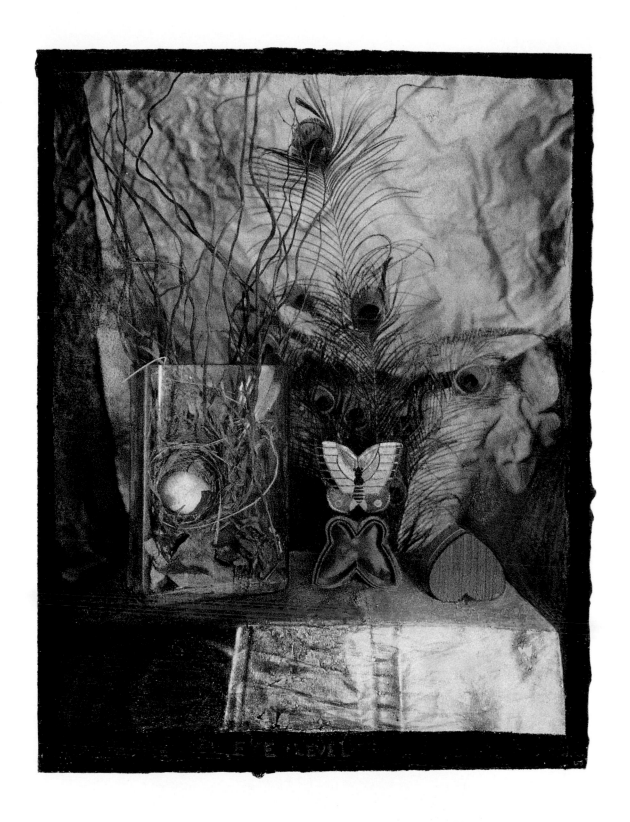

Tracie Taylor

Tracie Taylor, a photographic artist living in Richmond, Virginia, has exhibited her work from coast to coast. The drama in her imagery comes from her taking familiar objects and rendering them in complex, abstract designs. Taylor says, "My artistic objective is to present the object as I see it, rather than simply as how the camera records it. I selectively frame the image so that there is no reference as to where it was photographed."

Referring to her enjoyment of coloring books as a child, Taylor says that now she uses a camera to create images to color with Marshall Photo-Oils, rather than with the crayons she once used. Initially, she was put off by handcoloring because she thought she could obtain only light tints with it, but after experimentation, she was able to develop the strong colors she prefers. To make these two images, Taylor used paper with fine-grain, matte surfaces: "Machine Abstract C-2" was printed on Kodak Polyfiber G-surface paper, and "Jungle Series C-6" was printed on Agfa Brovira 119.

Taylor has found that the coloring process is easier if she first does a mock-up of the colors she intends to use in the final image. To make the mock-up, she places tracing paper over the print or a smaller version of the image and uses pencils to determine which colors she likes. Then she tapes the actual print to be painted onto a clean drawing board and begins handcoloring it.

She favors Marshall Extra Strong Photo-Oils, either directly from the tube or mixed, to create the rich, dark hues she seeks. If the color is too intense, as it can be when certain colors are used on Kodak Polyfiber paper, she mixes a small amount of Extender into the color to thin it. She applies the colors to the print with cotton-wrapped skewers or cotton balls. For her darker, more intense hues, she applies the photo oils more generously, carefully rubbing the area with the same cotton ball to even it out. To make lighter hues, she rubs harder and uses fresh cotton to absorb more of the oils.

Taylor begins with the largest area first. If an area features straight lines and no adjacent color, she will use plastic tape to mask the section. This makes handcoloring easier and faster, although she warns that the tape must be removed carefully in order not to damage the print surface or tear the emulsion. To erase mistakes and recover highlights in the photograph, she uses Marshall's Marlene solution. When the handcoloring is finished, she puts the print in a dust-free environment, preferring an archival box for that purpose, which is an excellent suggestion.

MACHINE ABSTRACT C-2

Jungle Series C-6

Bob Wade

Bob Wade is an artist who has been described as a master of "Texas Funk"; he is famous for taking kitsch and turning it into art in some big ways. As a sculptor, he has created some gigantic pieces, including a 63-foot tall saxophone that recently appeared in Houston, a pair of enormous Texas boots now on display at an upscale San Antonio mall, and a huge iguana for the roof of New York City's Lone Star Cafe.

In his photography, Wade, who resides in Santa Fe, is no less outrageous. His work usually is large scale, 4 x 6 feet or so, printed on Photo Linen, and colored with acrylics or oils, including photo oils. Humor and insight, nostalgia and curious juxtapositions surface in his images.

Friends from all over the country send him postcards from the twenties and thirties, depicting the American West as it likely never was, and he relishes enlarging these images and handcoloring them, too.

Roy Rogers is a second cousin on his mother's side, so Wade grew up with firsthand knowledge of the fantasy West during a time when little boys wore six guns and imagined good and bad in terms far different from today. His choice of subject matter helps us look at the past in a pleasant, if irreverent, way. The scale of his work—all printed here on Photo Linen, which blurs the distinction between photography and painting—allows us to appreciate his subjects in ways that would be lost in smaller formats.

HOFFBRAU, 4 x 6 feet.

WOOLY BOY, 36 x 24 inches

Cowboy Bar, 4 x 6.5 feet.

UP-TO-DATE COWGIRLS, 4 x 8 feet.

Cheryl Winser

Cheryl Winser, an artist living in Arlington Heights, Illinois, combines strong interests in photography and painting in her handcoloring work. Starting her career as a fine-art painter, she later became a graphic designer and then a photographer. In workshops on handcoloring in Chicago, she covers the basics of handcoloring photographs and encourages participants to have fun experimenting with color. She produces work for greeting cards, galleries, and a variety of clients, including other photographers. A commercial artist, she handcolors their photographs for advertising, editorial, and corporate clients.

About coloring other people's prints, Winser explains that "it can be difficult to blend the visions of two different people into a successful piece, but under the best circumstances, it is a wonderful way to collaborate. One photographer with whom I work is so creative, so dynamic, that I find I've always learned something from the experience of working together. That is really exciting!"

Winser doesn't have a particular favorite among photographic enlarging papers. Matte or semi-matte surfaces are important to her, but there is a tremendous range of paper within those categories. She usually starts coloring a print with Marshall Photo-Oils, then applies a bit of pencil or pastel. Some of her work is done exclusively in oils, other pieces are entirely the product of colored pencils, but most often she chooses to combine different media.

She says that she finds herself repeatedly drawn to quiet subjects because "handcoloring seems to enhance the mood of these photographs and evokes feelings and memories we associate with certain places, events, and people in our lives." Some of her still lifes are imaginary events "reflecting small moments in women's lives, and some are more personal, such as the dress my daughter wore to her first dance, my mother's pearls laid out on a lace blouse, and my niece playing dress up: life's little pleasures."

WHITE DRESSER WITH HYDRANGEA

HAT WITH RIBBONS

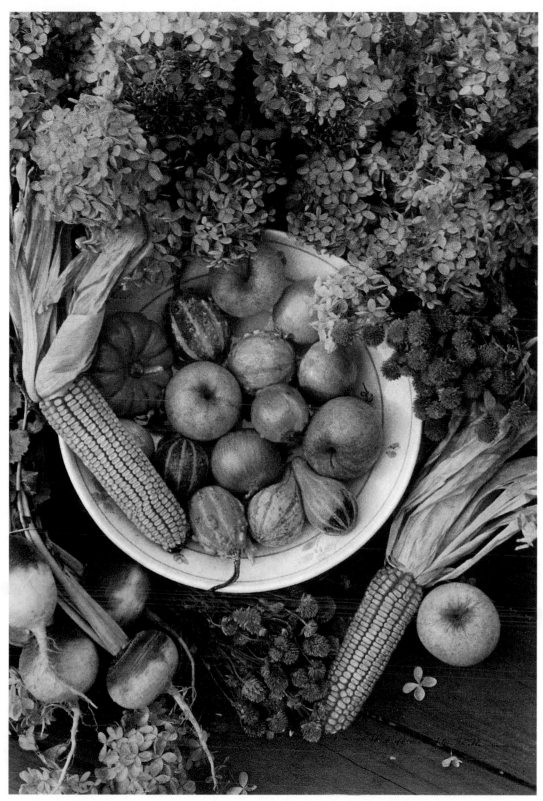

WINTER VEGETABLES WITH HYDRANGEA

SATIN HEART WITH ROSES

ELIZABETH'S LACE BLOUSE

To make a strong, graphic statement, I handcolored this fashion photograph by using ultracolor in just one area of it, leaving the rest of the image in black and white.

Appendix

ALTHOUGH IT MAY BE PRESUMPTUOUS to speculate about where handcoloring is headed, there are reasons to believe it has a rosy future as a commercial and a fine art. The fact that there is no real correlation between handcoloring and "color reality" opens many doors for handcoloring in the graphic arts. While some computer artists claim that they can manipulate images in the same way, they're missing the appeal that handcoloring has for both the viewer and the practitioner. As technology races ahead, making our lives both easier and more complicated, there is still pleasure to be had from simply creating something by hand from the imagination. The future of handcoloring is healthier than it has ever been, and the interest on the part of so many artists to appreciate, learn, and experiment with it indicates that this is just the beginning of a genuine renaissance in this area of photography.

COMMERCIAL DIRECTIONS

As a new medium, handcoloring offers quite a lot of commercial potential, including portraiture, boudoir photography, fashion, photo restoration, and advertising photography. Handcolored images are very popular with the print media and are even used by television and video shows as graphic elements. Obviously, enterprising photographers will probably pursue handcoloring work in overlapping areas, but it is helpful to consider each direction separately.

Although handcolored portraits are often associated with vintage styling, handcoloring can easily be promoted as a way to create strikingly contemporary images, too. While studio shots are simple to design for nostalgic portraits with old-fashioned sets and costuming, why leave handcoloring there? As a portrait photographer, you can emphasize clean, modern graphics and use color for special effects, such as minimal color or even ultracolor if the client wants it. Your goal should be to tailor your handcoloring capabilities to your clients' individual needs.

Keep in mind that handcoloring doesn't mean rendering everything in "realistic" color; instead, you can offer artistic impressions of your subjects for their consideration, something they might not be able to get in a traditional photography portrait. Not only is this a chance for you to be creative, it is also an opportunity to offer a premium service and charge your clients accordingly. Obviously, a photographic portrait that has been handcolored should cost more than one that was printed in a giant color processor. I suggest that you review the various techniques presented in this book and determine which would be appropriate to offer to your clientel, then deduce how much you think this extra service should cost as you go an extra mile to please them.

Children's portraiture merits special mention. If you get a lot of pleasure from observing and photographing children, this is one of the most promising ways to use handcoloring. Although many parents settle for bargain packages offered by schools and department stores for photographs of their children, some parents would like and will pay for more personal, special images of their children's fleeting youth. Handcoloring, particularly in an impressionistic manner, is a perfect vehicle for capturing the magic of childhood. This is not the kind of photography where a child is routinely photographed in front of a backdrop; I'm talking about being willing to venture off the set to make really personal, spontaneous portraits. For whatever reasons, women seem to have more interest in and ability to photograph children this way. If you share this interest, my advice is to couple it with your handcoloring skills in order to offer something truly special.

Another area of portraiture that is especially well suited for handcoloring is boudoir portraits. The minimal color technique described in this book, combined with the soft lighting characteristic of boudoir images, can be used to produce handcolored masterpieces. Although this genre has unfortunately been cheapened by slobs who strap on cameras and ask women to take off their clothes, I prefer to think of a boudoir portrait as a unique romantic study of an individual intended as a gift for someone special, which is the way I do it. I only work on location and am always aware that I am dealing with a subject who is particularly vulnerable. By this, I mean that the person is appearing before me in a sensitive, personal way, with a desire to be idealized.

The boudoir subject's ego is therefore very vulnerable, so care must be given to making her feel at ease and comfortable, and secure enough for the desired expression to come through in the images. Personal space is essential for establishing the subject's feeling of security; touching is unprofessional; and insensitive, jocular remarks or suggestive innuendo will spoil the mood necessary to create a romantic image. Yet, if you accept these groundrules and abide by them, you can then enhance the beauty of the boudoir portrait by handcoloring it.

Fashion images borrow from both commercial and people photography, and fashion work is another great area for handcoloring. You can tailor a fashion shoot to a particular situation, a vintage costume, a period costume from the 'fifties, or a radically contemporary appeal. One way to promote handcolored fashion work is, for example, to offer it to a model as a part of an overall package of black-and-white and color images. Or you could suggest to a boutique owner that it is worth the added expense to create a special look for their advertising program. Maximize whatever opportunities you already have to add to your existing business services by incorporating handcoloring.

Taking a different tack, you may want to consider using your handcoloring skills to do photographic restoration of old images, a practice that is probably as close to the roots of traditional handcoloring as exists today. There is an excellent market for this service. If you're interested in pursuing it, I suggest that you contact photographers in your area who already offer photo copying and restoration services and find out if they would like you to subcontract your skills as a handcolorist as an option for their clients. The alternative is to become a specialist in photographic restoration yourself. As you may know, computer software programs have completely revolutionized the retouching business.

Another of my ultracolored photographs was used on a poster to promote the San Antonio Festival.

For photographic restoration, if you are inclined to use this software, you can create an excellently retouched negative from which to produce an archival, restored print for handcoloring. A minimal color approach is often the best way to handcolor old images. Whether you do work for a restoration specialist or become one yourself, this can be a very lucrative activity.

Handcoloring for commercial and advertising accounts is still a relatively new field but one that is growing fast. Handcoloring is being explored in ways your parents never imagined; it also can be used to conjure up comforting associations with the past. Advertisers are taking advantage of both the new and the old aspects, and are using more and more handcolored photographs in print ads and promotions. If you have clients—individuals or businesses—who are looking for an "edge," something to set them apart from the competition, handcoloring can provide them with that special image.

I know one handcolorist who confidently charges premium prices for work for advertising clients, although doing such commercial work is only a part-time activity. He commands top dollar because there aren't any other handcolorists in his area. Keep this in mind when you start to figure out how to bill your clients for commercial work. Remember that while there are numerous studios equipped for product or architectural photography, there are very few that offer creative handcoloring services. Also, many handcolorists wish to remain identified as fine artists rather than crossing over into the commercial arena, which limits the competition for commercial work. If you are a photographer who wants to expand into commercial handcoloring, I suggest you show prospective clients examples of your other photography, too; this will help illustrate your range of style.

Also, you should decide in advance whether or not you're willing to handcolor pictures taken by other photographers. Essentially, if you want to be a photographer first and a handcolorist second, then you should probably reject requests to do handcoloring alone. On the other hand, this could mean turning down lucrative assignments. Here is a case in point that occurred nearly a decade ago: I agreed to handcolor fifty photographs to be taken by another photographer who had already been commissioned to photograph the lengthy assignment. The reasons I took the job were because the pay was excellent and because it would showcase my handcoloring work regionally. The finished images were beautiful, and I was proud when I took one of the brochures in which they were printed fresh off the press on a trip to New York City. However, upon seeing it, the first question many people asked me was why, if I were also a photographer, I hadn't been chosen to shoot the photographs as well. The inquiry stung me, as it became clear that some were assuming that my photography had not passed muster with the managing art director who put the project together. While that conclusion was incorrect, consider whether or not you will mind people jumping to it.

You must decide whether you want to do handcoloring work for the widest possible audience—and thereby potentially sacrifice some of your photographic reputation—or whether you will voluntarily restrict yourself to doing only certain kinds of jobs, in effect, forcing art directors to hire you as both the photographer *and* the handcolorist. A third alternative is to forego commercial handcoloring altogether and use handcoloring only for fine-art work. Whatever you decide, I hope you have as much fun and get as much satisfaction from handcoloring photographs as I have. Good luck!

INDEX